W9-BZI-468

RODIN

MUSEUM

Handbook

by John L. Tancock

Philadelphia Museum of Art

1 9 6 9

My warm thanks are due to Mrs. Dorothy Headly both for her initial enthusiasm for this project and for her constant cooperation during its execution.

J.L.T.

Cover: **The Gates of Hell** (detail)

Acknowledgment is made to Citadel Press Inc. for permission to quote from the translation of Baudelaire's "La Beauté."

Copyright © 1969 by the Philadelphia Museum of Art
Printed in the United States of America

Library of Congress Catalog Card Number: 70–101487
Standard Book Number: 87633-008-1

CONTENTS

Preface 7

The Museum and the Collection 9

Rodin—The Sculptor 13

Major Events in Rodin's Life 18

Note on the Bronze Casts 21

"The Gates of Hell" and Related Works 23

Small Groups and Figures 41

Major Works 53

Portraits 66

Allegorical Portraits 83

Fragments and Assemblages 87

Drawings and Prints 94

Index of Works in the Museum 101

PREFACE

The history of Philadelphia is marked by an extraordinary succession of benefactors who have enriched or assisted the life of the community in a variety of ways. One of the most remarkable of these figures was Jules Mastbaum. In the fiftieth year of a highly productive life, he suddenly discovered the excitement of the great French sculptor Auguste Rodin, his enthusiasm was such that in less than three years he had with a characteristic energy acquired close to two hundred works with the intention of creating a public collection to enrich the lives of the people of Philadelphia.

That he should not have lived to enjoy the fruition of his dream and the fame his achievement has brought his city is a sad irony. However, the collection has had a significant impact upon the steadily increasing admiration for Rodin that has developed in the United States since the Second World War. Celebrating the fortieth anniversary of the opening of the Museum with the publication of a new *Handbook* should encourage a wider appreciation of the qualities that so moved Mr. Mastbaum.

Evan H. Turner
Director
Philadelphia Museum of Art

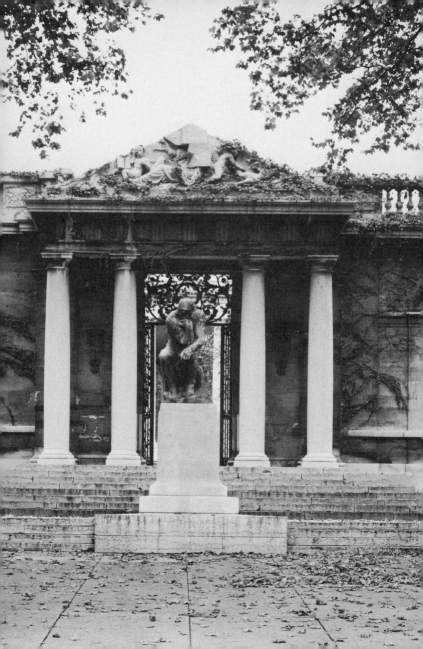

THE MUSEUM

AND THE COLLECTION

The Rodin Museum and its collection were given to the City of Philadelphia by Jules E. Mastbaum, a leading figure in the motion-picture industry and head of the Stanley Company of America, as well as one of Philadelphia's best-known philanthropists. Jules Mastbaum began to pursue an interest in collecting art in 1922, when he commissioned Albert Rosenthal to purchase works of art for him in Europe. The following year, on a visit to Paris, Mr. Mastbaum bought a small bronze by Rodin which so fired his enthusiasm for this artist that he conceived the idea of establishing a Rodin Museum in Philadelphia. This plan met with the complete approval of the Musée Rodin in Paris, to which Rodin had bequeathed all of his works and vested control of their casting. Mr. Mastbaum began to purchase bronzes directly from the Musée Rodin in 1924, and by 1926 had acquired most of the works in the collection. Some of the bronzes were duplicates of works that had already been cast during Rodin's lifetime; others, however, were cast especially for him. Most important among these is the cast of *The Gates of Hell,* which had been left in plaster at Rodin's death in 1917. The first cast was kept for the Museum in Philadelphia and the second was given to the parent institution in Paris. Mr. Mastbaum did not limit his pur-

chases to bronzes. Feeling that his museum ought to give as complete a view as possible of Rodin, he purchased drawings, prints, letters, books, and a variety of documentary material. This material is now divided between the Rodin Museum and the Philadelphia Museum of Art.

But Mr. Mastbaum's interest in Rodin went beyond establishing the Museum and collecting his works. He contributed funds for the rehabilitation of Rodin's home and studios at Meudon, which were by that time in a state of total disrepair. In return for this generosity, the French Government presented Mr. Mastbaum with six of Rodin's plasters.

While the collection was being formed, the Philadelphia architect Paul P. Cret and the French architect Jacques Gréber were commissioned to design the Museum building and the formal garden that surrounds it. A replica of Rodin's tomb was planned for the entrance to the garden. The gateway reproduces the facade of the Château d'Issy, which had been reconstructed on Rodin's property at Meudon in 1907. The cast of *The Thinker* is in a location similar to that of the one at Meudon that serves as Rodin's headstone.

In April, 1926, Jules Mastbaum offered to erect and maintain the building on the Parkway to house his collection of the works of Rodin for "the enjoyment of my fellow-citizens." This offer was formally accepted by the Commissioners of Fairmount Park on May 12, 1926. Unfortunately Mr. Mastbaum died suddenly on December 7, 1926, before construction had been started. However, his will authorized his executors and trustees to complete the Museum. His widow, Etta Wedell Mastbaum,

on behalf of the trustees, then proposed completing the building and transferring the collection to the City of Philadelphia, with the provision that the City assume responsibility for its maintenance. These conditions were accepted by the City, and on December 7, 1927, the date of the first anniversary of Mr. Mastbaum's death, ground-breaking ceremonies took place on land at the junction of Twenty-second Street and the Benjamin Franklin Parkway. The museum was finally opened to the public on November 29, 1929. Ten years later an agreement was reached whereby the Commissioners of Fairmount Park constituted the Philadelphia Museum of Art as their agent to administer the Rodin Museum and care for the objects of art which were placed there.

Fortunately the collection of the Rodin Museum did not remain static after Mr. Mastbaum's death. In 1953 Paul Rosenberg donated the handsome white plaster of *Eternal Springtime,* the original that Rodin presented in 1885 to Robert Louis Stevenson. In 1967 the Committee of the Museum generously presented a set of the famous photographs of Rodin and his sculpture taken by Edward Steichen in 1908. Finally, in 1968, the bust of Etienne Clémentel, Rodin's last work, was acquired for the Museum with funds from the W. P. Wilstach Collection. It is hoped that the collection will continue to grow.

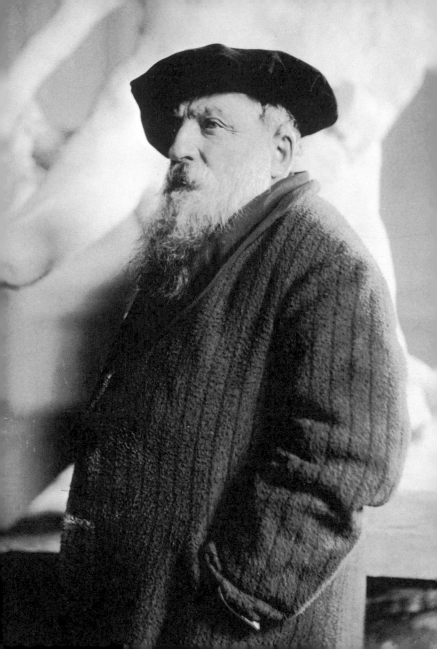

RODIN

THE SCULPTOR

Few artists have been more widely revered than Rodin was during the latter part of his life. Of the same generation as Claude Monet, Paul Cézanne, and Auguste Renoir, Rodin had the satisfaction before he died of seeing a room in the Metropolitan Museum of Art in New York and an entire museum in Paris devoted to his work, while the paintings of the other masters were then only beginning to enter public collections. In a century of artistic scandals, however, Rodin had no rival in his ability to create far-reaching controversies that occasionally even had political overtones. The exhibition of each major work—*The Age of Bronze*, the monuments to Victor Hugo, Claude Lorrain, President Sarmiento, and most notorious of all, Balzac—gave rise to hostile press campaigns, acrimonious debates, and prolonged disputes.

In the sense that sculpture is a more public art than painting, it is not surprising that the debates regarding the merits of Rodin's art were so extensive. But it is surprising that a sculptor should have been accorded such treatment in nineteenth-century France, for the century was primarily one of great painters. Great sculp-

Auguste Rodin about 1907

tors there were — Rude, Barye, Carpeaux — but they were exceptions, individualists in a field where the majority of sculptors conformed to ossified neo-classical formulas derived from Jacques-Louis David and Canova. To the young Rodin, fired with enthusiasm for the great colorists, Titian, Rembrandt, and Delacroix, the frigid conventions of neo-classical sculpture, with its intellectual bias and its idealization of form, had nothing to offer. The *Mask of the Man with the Broken Nose,* which he later regarded as his first good piece of modeling, shows how remarkably sure the young artist was of the values he wished to perpetuate. Rodin was obliged to produce commercial decorative sculpture to make a living when he did this mask, but it reveals an altogether different concept of the sculptor's craft and duties from that prevailing in his commercial work.

Many years later, in his illuminating conversations with Paul Gsell, Rodin gave clear expression to the principles that, even at this early date, lay behind his refusal to regularize the features of his model Bibi (see no. 71). He explained that it had always been his aim to be servilely faithful to Nature, to copy exactly what he saw. He thought it wrong for the artist to choose "beautiful subjects" since for the artist "everything in Nature is beautiful," beauty being defined as that which has character. Believing this, he rejected no models simply because they were ugly by conventional standards. Rejecting only the hackneyed poses of the professional model—preferring, in fact, untrained to trained models—he encouraged them to move freely about the studio, observing them all the time and making countless sketches, both in clay and in pencil and wash. In his self-willed subservience

to Nature, he attempted to register every profile of the model; moving round and round, observing from above and below, he strove to make the contours of his model and those of his clay coincide exactly. He looked on his work in three dimensions as a form of drawing in space.

It is a combination of the outer realism that results from this approach and psychological penetration that characterizes Rodin's entire oeuvre, from the minutest fragment to the immense dramas of *The Gates of Hell* and *The Burghers of Calais*. The uncanny insight that enabled him to penetrate the masks of the many distinguished and as many anonymous men and women he portrayed, enabled him to create with absolute authenticity effigies of the dead *(Claude Lorrain, Balzac)*, scenes from the historical past *(The Burghers of Calais)*, and scenes from literature (the poetry of Dante, Ovid, and Charles Baudelaire, providing the main inspiration for the turmoil of *The Gates of Hell*, and the countless works on mythological themes).

Rodin's immense productivity is a constant source of wonderment. Visitors to the studio reported that he was seldom to be seen without a lump of clay in his hand and that when this was not available he would satisfy his urge to create with crumbs from the dinner table. If a commission appealed to him, he would accept it, regardless of whether or not he was currently occupied with other undertakings. He would agree to deadlines that he had no hope of meeting. Each major work was preceded by many studies both of the whole and of parts, many of which survive. In the case of the smaller works and of the portraits, there might be a number of states which differ importantly from each other in detail.

A further factor to be considered in surveying the vastness of Rodin's oeuvre is that, from a relatively early stage in his career, he employed a considerable number of assistants—each a specialist in a particular stage of creating a sculpture—many of whom later became famous in their own right. Rodin, in fact, was the head of an atelier, organized along the lines of that of a Renaissance master. Although contrary to common belief he did a certain amount of the carving himself, much of the preliminary work was done by his assistants under his constant and exacting supervision.

Thus it is not uncommon for Rodin's works to exist in a number of versions, varying from the spontaneous preliminary sketches to the studied finality of the statement in bronze or marble. In recent years it is the "unknown" Rodin, the creator of the small informal studies, that has become popular, even fashionable, at the expense of the widely revered artist of the end of the nineteenth century, the creator of public monuments and of dignified busts. Although it is fascinating to observe the artist in the intimacy of the act of creation, the fragmentary nature and bold ellipses of these works should not blind the contemporary spectator to the fact that Rodin can be seen at his most complete in his most carefully considered works. This is not to deny that one of his most important contributions to the development of modern sculpture was his exhibition of partial figures and of fragmentary studies as complete works of art. It has already been pointed out that it was his aim to maintain an equal level of intensity throughout his scrutiny of the entire figure. Refusing to subject it to a stylization in which certain parts of the body played a role of less

importance than others, he came to feel that any part of the body, however small and apparently insignificant, could in itself constitute a complete sculptural statement, provided it was the embodiment of a truthful observation of Nature. "Works which are called 'finished' are works which are clear, that is all," he stated on one occasion.

This apparent lack of finish has led many commentators on Rodin's work to state that he was an Impressionist, the sculptural equivalent of Renoir and Monet. It is true that the rough, light-catching surfaces of many bronzes do bear a superficial resemblance to the granular appearance of many Impressionist paintings. However, an analysis of the function of this roughness reveals that the resemblance is limited to appearance only. The surface rugosity of his work is evidence not of an interest in the impingement of light on the figure, as is the case with the work of Medardo Rosso, but of his desire to give as complete a rendition as possible of the form. It may be convenient to think of Rodin as an Impressionist since he was the exact contemporary and a friend of many of the leading figures in the movement, but to do so reduces his stature considerably. Certain characteristics he does share with them—principally his penchant for fleeting expression, for the previously unrecorded moment—but there is no equivalent in the work of the Impressionist painters of Rodin's emotionalism, his psychological approach to character, his historicism, his symbolism, or his urge to create works of monumental proportions.

At a time when the art of the avant-garde was characterized by a narrowing of interests—in particular the Impressionists' passionate concern with fleeting light effects—Rodin was able to retain the universal curiosity

and versatility of the Old Masters. He was criticized during his lifetime for his modernity, but to the contemporary spectator his ties with the past seem at least as strong. Immediately after his death, his reputation, along with that of the Impressionist painters, went into a serious decline. Today, however, with his return to favor, Rodin can be seen not merely as an artist who worked in a relatively restricted style at the end of the nineteenth century but as one of the truly great sculptors of the Western world.

MAJOR EVENTS IN RODIN'S LIFE

1840	November 12. François-Auguste-René Rodin is born in Paris.
1854	Enters the Ecole Spéciale de Dessin et de Mathématiques ("Petite Ecole"), where he is a student of Horace Lecoq de Boisbaudran.
1857	Fails the entrance examination for the Ecole des Beaux-Arts three times. To support himself and his family, he accepts a number of menial jobs working for commercial and decorative sculptors.
1862–63	Upon the death of his sister Maria, he enters the religious order of the Society of the Blessed Sacrament. After executing the bust of the founder of the order, Father Eymard, he returns to the world, acting on the latter's advice.
1863	Begins *The Man with the Broken Nose*.

1864	Meets Rose Beuret, who becomes his mistress. Enters the atelier of the fashionable sculptor Carrier-Belleuse, and works for him until 1870.
1870	Enlists in the National Guard during the Franco-Prussian War.
1871	Discharged from the army because of near-sightedness, he goes to Belgium to work again for Carrier-Belleuse, who has moved there. During the next three years, works on monumental decorative sculpture in Brussels and Antwerp.
1875	Begins *The Age of Bronze*. Late in the year, travels to Italy and studies the works of Michelangelo in Florence.
1877	*The Age of Bronze* is exhibited in Brussels and in Paris. He is accused of having cast his figure directly from the model.
1878	Begins *St. John the Baptist Preaching*.
1879–82	Works intermittently under Carrier-Belleuse at the Sèvres porcelain factory.
1880	Receives the commission for *The Gates of Hell*, on which he works intensively throughout the 1880s.
1881	Makes his first visit to England at the invitation of his friend, the painter Alphonse Legros. Does his first drypoints.
1884	Is awarded the commission for *The Burghers of Calais*, on which he works during the following decade.
1889	Receives the commissions for the *Monument to Victor Hugo* for the Panthéon in Paris and the *Monument to Claude Lorrain* for the city of Nancy.

1890	His project for the Victor Hugo monument is rejected as unsuitable for the Panthéon. Begins work on a second monument to the writer.
1891	The Société des Gens de Lettres commissions a *Monument to Balzac*.
1894	Receives the commission for the *Monument to President Sarmiento* of Argentina.
1895	*The Burghers of Calais* is unveiled at Calais.
1898	The *Monument to Balzac* is exhibited at the Salon but the Société des Gens de Lettres refuses to accept it. This sequence of events, which has political overtones, leads Rodin to withdraw his figure from the Salon.
1899	The first important one-man show of Rodin's work is seen in Brussels, Rotterdam, Amsterdam, and The Hague.
1900	Rodin's first major retrospective exhibition opens in conjunction with the International Exhibition in Paris. His reputation grows immeasurably on both sides of the Atlantic. During the next decade, he makes a large number of busts of prominent members of English and American society.
1906	Makes many drawings of the Cambodian dancers who are appearing in Paris, and follows them to Marseilles.
1908	Edward Steichen takes a famous series of photographs at Meudon. Begins living at the Hôtel Biron, in Paris, as well as at Meudon.
1911	The British Government purchases a cast of *The Burghers of Calais,* to be set up near the Houses of Parliament.

1912	The Rodin Room in the Metropolitan Museum of Art, New York, is opened to the public.
1914	His writings on the Gothic are published as *Les Cathédrales de France*. Presents eighteen sculptures to the Victoria and Albert Museum, London. Travels to Rome to do a portrait of Pope Benedict XV, but cannot arrange for sittings.
1915	Returns to Rome and successfully arranges to model the bust of the Pontiff.
1916	In three donations, he formally offers his work and collections to the French State.
1917	January 29. Marries Rose Beuret.
	February 14. Mme Rodin dies.
	November 17. Rodin dies at Meudon.
	November 24. Rodin is buried at Meudon.

NOTE ON THE BRONZE CASTS

It is sometimes assumed that for a Rodin bronze to be original it must have been cast before the date of the artist's death in 1917. However, this is not the case. When Rodin died, he left his entire estate, including the molds of unedited (uncast) works, to the French State. The Musée Rodin, as his legatee, was authorized to make bronze casts from the original molds in editions limited to the number of twelve. All the bronzes issued by the Musée Rodin were cast by the foundry of Alexis Rudier, who had begun to cast most of Rodin's bronzes in 1902.

Alexis Rudier died in 1922, but his son Eugène ran the foundry until his death in 1954, continuing to use the foundry mark of his father, "Alexis Rudier/Fondeur Paris." Thus the bronzes bearing this particular mark may have been cast at any time between 1902 and 1954. After Eugène's death, the Musée Rodin contract passed to his nephew Georges Rudier who established a new foundry, retaining, however, some of his uncle's employees. All bronzes cast since 1954 bear the foundry mark, "Georges Rudier/Fondeur Paris," and are inscribed with the date of casting and the number of the cast in the edition of twelve. The majority of the bronzes in this collection were cast especially for Mr. Mastbaum by the foundry of Alexis Rudier between 1924 and 1926. Only four (nos. 26, 31, 44, 94) are known to have been cast before 1917 by other founders.

USE OF THIS HANDBOOK

For each work, the date given is that of the original conception, not of the casting in bronze, carving in marble, enlargement, or reduction. Only when these dates are known or can be reasonably surmised have they too been given. This Handbook is an abridgment of a full-scale catalogue of the collection of the Rodin Museum scheduled for publication in 1971. Of necessity, changes in the traditional dating of works are made without full presentation of the evidence; for full documentation, readers are asked to await the publication of the catalogue.

In citing dimensions, height precedes width followed by depth.

"THE GATES OF HELL"

AND RELATED WORKS

1. The Gates of Hell

1880–1917. Bronze, 250¾ x 158 x 33⅛ in.

The Gates of Hell, which occupied Rodin from 1880 until 1917, the year of his death, is the culminating achievement of his career. In this vast panorama of writhing figures, his genius may be seen at its most daring and dramatic. In 1880 he received the commission from the Ministry of Fine Arts for a monumental portal for the proposed Museum of Decorative Arts in Paris. This provided him with an opportunity for modeling a large number of figures on a small scale, thereby refuting the current accusations that he could not model the human figure without the assistance of casts taken from life. Having already modeled a group of *Ugolino and His Sons,* Rodin turned to Dante's *Inferno* again for his subject matter, and to Ghiberti's Baptistery doors, which he had seen in Florence in 1875, for the architectural plans. A study of the preliminary architectural drawings and models reveals the gradual abandonment of the traditional paneled door in low relief with representations of separate scenes in favor of the much more sculptural concept of two large panels surmounted by a tympanum and framed by decorative pilasters. Stating that his whole idea was one of "color and effect," Rodin gradually eliminated almost all particular references to Dante's

poem, retaining only the groups of *Ugolino and His Sons* and *Paolo and Francesca* near the bottom of the left panel.

The suffering of the damned is conveyed, nonetheless, through the agonized and despairing gestures of the 186 figures who clamber precariously over the entire surface of the *Gates*. On the two pilasters are represented souls relegated to Limbo, those who died in ignorance on the left and doomed lovers on the right. In the deep recesses of the tympanum sits *The Thinker*, contemplating the tragic fate of mankind. To the left the ceaseless arrival of damned souls in Hell is suggested by the strongly emphasized downward movement of the figures, while to the right they can be seen being cast down into Hell. On the leaves of the *Gates*, the damned writhe in agony, reliving endlessly the torments that assailed them during their life on earth, all hope of escape seeming to be blocked by the emphatic downward gesture of *The Three Shades* who stand on top of the tympanum.

Throughout the 1880s Rodin worked intensively on the *Gates*, adding and subtracting figures and experimenting with them in different positions. Thereafter work on them became more intermittent, but he continued to draw on the *Gates* as a source for many independent sculptures. About 1899, when the *Gates* seemed near completion, Rodin began to feel that they were lacking in architectural qualities and ripped off most of the projecting parts. It was in this state that they were first exhibited in Paris at Rodin's large retrospective exhibition in 1900. During the years 1908–10, he directed the reconstitution of the *Gates*, but never restored the cut-off molding on either side of the leaves of the door. Because

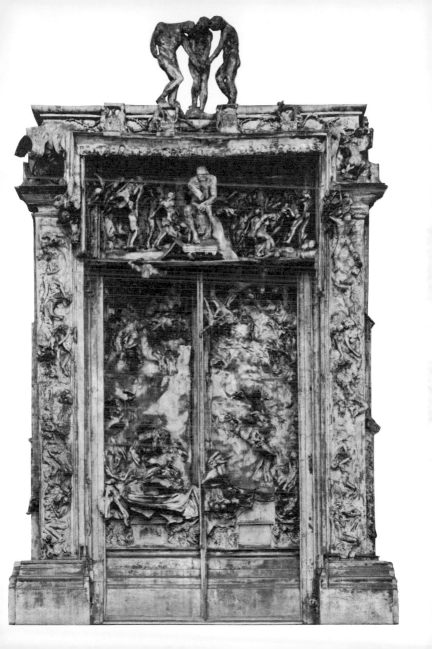

of Rodin's declining health and the outbreak of war, no further work was done on the *Gates,* and they remained unfinished at the time of his death.

When Jules Mastbaum first saw the *Gates* in 1924, they had still not been cast in bronze. He ordered two bronze casts, the first for his own museum in Philadelphia and the second for the Musée Rodin in Paris. There are now two other casts, one in the National Museum of Western Art, Tokyo, and the other in the Kunsthaus, Zurich.

2. Third Architectural Model for "The Gates of Hell"

1880. Terra cotta, 39½ x 24¾ x 6¾ in.

The third clay model for *The Gates of Hell* shows Rodin's increased interest in the sculptural possibilities of the surfaces of the doors. The four male figures on the pilasters, as well as the groups of *Paolo and Francesca* (on the left leaf) and *Ugolino and His Sons* (on the right leaf), are all in high relief. The remains of the separate panels can still be seen, but the anonymous figures have begun to spill out and clamber over the confining edges. In the final version of the *Gates,* only the figure of *The Thinker* remains in the same position. *Ugolino and His Sons* has been moved to the left panel, while the upright embracing group of *Paolo and Francesca* has been omitted (this version developed into the statue-in-the-round known as *The Kiss),* and replaced by another version of the same theme in which the two lovers are positioned horizontally.

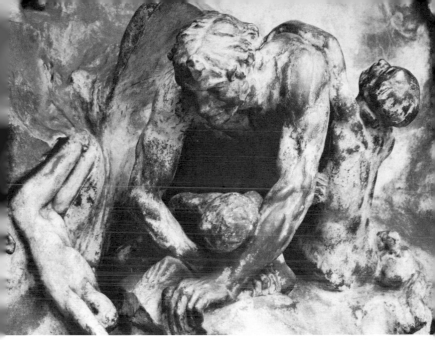

3. The Thinker

1880 (enlarged 1902–4)
[a] *Bronze, 27⅛ x 15¼ x 19¾ in.*
[b] *Bronze, 79 x 51¼ x 55¼ in*
 (situated on the Parkway in front of the Museum)

The early drawings and the third architectural model
(no. 2) show Rodin's need for a figure as the focal point
of *The Gates of Hell.* He first thought of the figure in the
tympanum, now universally known as *The Thinker,* as
the poet Dante contemplating his creation. Later he con-
ceived another thinker, a naked anonymous man, seated

on a rock, head on hand, right elbow on left knee, thinking not only with his brain "but with every muscle of his arms, back and legs, with his clenched fist and gripping toes." After this sculpture had been enlarged, it was exhibited in 1904, making such an immediate impression that a subscription was raised and a cast of the sculpture was presented to the City of Paris. Since then it has achieved world-wide popularity and inspired a variety of interpretations. Today it has become a symbol, not of the poet or superman, but of hope and belief in man's resourcefulness.

4. Adam

1880. Bronze, 75½ x 29½ x 29½ in.

Following his visit to Italy in 1875–76, Rodin modeled a figure of *Adam* in order to understand more clearly the art of Michelangelo. The figure was either abandoned or destroyed; later, this second version was made. It was intended, with the figure of *Eve* (no. 7), to flank *The Gates of Hell,* thereby showing the relationship of man's downfall to his suffering in Hell, but this idea was never carried out. *Adam* was later exhibited as a separate statue. Nowhere else in Rodin's art is the impact of Michelangelo seen so clearly.

5. The Shade

1880 (enlarged c. 1902)
Bronze, 75½ x 44⅛ x 19¾ in.

The Shade represents the soul of one of the damned encountered by Dante and Virgil on their journey through

the underworld. The enormously powerful figure seems to lack all motivating force, being prey to powers entirely beyond its control or understanding. It is strikingly similar to the *Adam* (no. 4), and likewise reveals the influence of Michelangelo. Early in the development of the *Gates,* three casts of this figure were arranged in a group and placed on the top of the tympanum immediately above *The Thinker.* At first it appears that they held a scroll on which was engraved the celebrated motto from above the entrance to Dante's Inferno — "Abandon all hope, ye who enter here" — but this was later removed, the figures themselves becoming a living embodiment of the message.

6. The Helmet-Maker's Wife

1880–83. Bronze, 19½ x 9¼ x 10½ in.

The old Italian woman who posed for this work may have knocked on Rodin's door when seeking her long-lost son, as popular legend has it, or she may have been a professional model who was recommended to him by a fellow sculptor. Rodin was greatly moved by her withered form, and this forced him to reconsider his notions of beauty and ugliness. He came finally to the conclusion that what is normally ugly can, by the touch of the artist's hand, become a thing of beauty. Through her sagging flesh, Rodin shows the accumulated hopes and sorrows of a lifetime. The title is taken from François Villon's ballad, "Les Regrets de la belle hëaulmiere" ("Lament of the Beautiful Helmet-Maker's Wife"). It is also known as *The Old Courtesan.* The same model

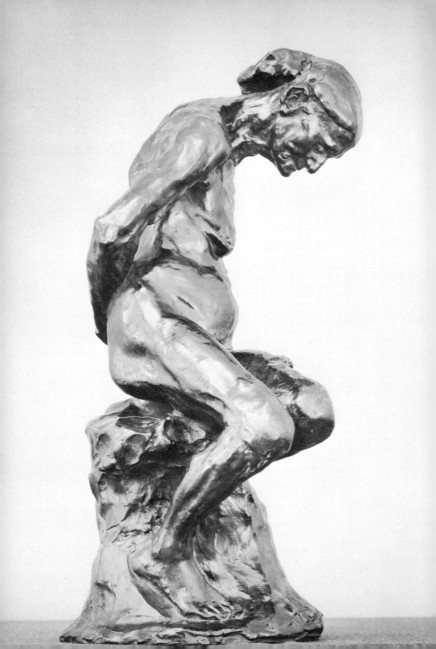

was used for the figure of the old woman directly above the group of the mother and child on the left pilaster of the *Gates.*

7. Eve

1881. Bronze, 67 x 18½ x 23¼ in.

It was probably while working on the figure of *Adam* that Rodin conceived the idea of modeling a figure of *Eve* and placing the tragic pair on either side of *The Gates of Hell.* Although the two were never used in that position, largely for financial reasons, they became famous as separate statues, with the *Eve* gaining immediate popularity. The rough surfaces on the head and face and on the stomach are to be explained by the fact that the model became pregnant during the time Rodin was working on the figure and disappeared suddenly before Rodin was fully satisfied that he had faithfully recorded all of the contours of her body.

8. Head of Sorrow (Joan of Arc)

By 1882 (enlarged 1907?)
Bronze, 17 x 19½ x 21¼ in.

A version of this head was first used in 1882 for the figure of the son pulling himself up onto his father's back in *Ugolino and His Sons.* Viewed separately about that time, it was called *Head of Sorrow.* Later it was used in a number of other works as well as several times in *The Gates of Hell* — as the head of Paolo in *Paolo and Francesca* and in the group that later became known as *Fugit Amor.* In 1905, in honor of the actress Eleonora

Duse, the same head was enlarged and given the name *Anxiety*. The first marble version of this very expressive head seems to date from 1904. Another marble version was probably carved in 1907; from its base the ends of wooden faggots can be seen emerging. Rodin returned to this project in 1913 when he was commissioned to make a monument to Joan of Arc, but this was never constructed. It is from the second marble that the Museum's bronze was cast although this was probably not done until the mid 1920s when it was commissioned by Mr. Mastbaum.

9. The Crouching Woman

1882. Bronze, 33 x 21 x 18 in.

Created when Rodin was still greatly influenced by Michelangelo, *The Crouching Woman* is one of his most agonized works. A closely related figure first appears in the tympanum of *The Gates of Hell,* seated to the left of *The Thinker*. With slight changes in the position of the limbs, the same figure was used in the group known as *I Am Beautiful* (no. 10). When the figure was detached and enlarged, as it is here, its pose became much more compact and expressive. In a later marble version in The Museum of Fine Arts, Boston, the woman holds a stone on her shoulder; it was probably intended to be used as part of a fountain.

10. I Am Beautiful

1882. Bronze, 27¾ x 12 x 12½ in.

To make this group, Rodin juxtaposed two figures from *The Gates of Hell* — the man falling from the lintel above

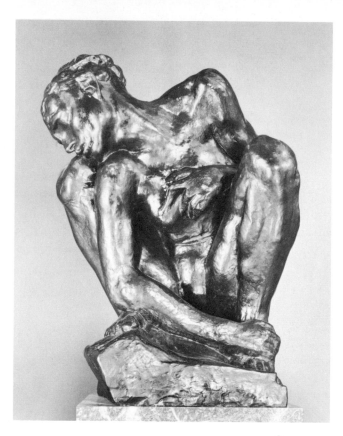

9

the left panel and *The Crouching Woman* to the left of
The Thinker—while the group itself can be seen again,
repeated in low relief at the top of the right pilaster.
In a slightly later version the figure of the woman is

replaced by an entwined serpent. In the extravagance of its passion, this is undoubtedly one of Rodin's most daring compositions. Its title is taken from the first line of Baudelaire's poem "La Beauté." The entire first verse is engraved on the base of the sculpture; in the translation of Arthur Symons it reads:

I am beautiful as a dream of stone, but not maternal;
And my breast, where men are slain, none for his
 learning,
Is made to inspire in the Poet passions that, burning,
Are mute and carnal as matter and as eternal.

11. Small Head

c. 1882. Plaster, 2⅜ x 1⅝ x 2½ in.

This small plaster is a study for the head of the *Despairing Youth* above the tomb at the bottom of the right panel of *The Gates of Hell.*

12. Kneeling Fauness

1884. Bronze, 21 x 8 x 10½ in.

This demonic figure kneels beneath two flying figures at the far left of the tympanum of *The Gates of Hell.* The contrast between the svelte curves of the body and the battered, ghoulish head makes the detached figure particularly enigmatic. With the two figures hovering above, it forms a group called *Orpheus and the Maenads,* but it is also related to a number of other kneeling female figures, including *Awakening (The Toilette of Venus),* of which a limestone version is in the John G. Johnson Collection in the Philadelphia Museum of Art.

13. Bas-relief for "The Gates of Hell"

LEFT SIDE

By 1885. Bronze, 12½ x 43½ x 6¼ in.

14. Bas-relief for "The Gates of Hell"

RIGHT SIDE

By 1885. Bronze, 12½ x 43½ x 5¾ in.

In the first years of his work on *The Gates of Hell*, Rodin had intended to place these bas-reliefs across the bottom of each panel. In the center of each is a mask of grief, while on both sides are violent scenes of centaurs carrying off struggling women. By 1900 these reliefs had been discarded because they disrupted the spatial coherence of the panels. The heads were detached and cast as separate works (nos. 15, 16).

15. Crying Girl

By 1885. Bronze, 8 x 5¼ x 5¼ in.

16. Mask of Crying Girl

By 1885. Bronze, 12¼ x 6¾ x 4½ in.

All the anguish of the damned on *The Gates of Hell* seems to be embodied in these contorted faces. They are taken from the bas-reliefs that Rodin intended for the bottom of the panels of the *Gates*. *Mask of Crying Girl* is close to the head in the left relief (no. 13) while *Crying Girl* is closer to the head in the right relief (no. 14).

17. Young Mother in the Grotto

1885. Plaster, 14 x 10 x 7 in.

Young Mother in the Grotto is one of the few later works by Rodin on the subject of maternal love. The figures are placed against the background of a hollow cavern, the walls of which partly support the child who touches the roof with his left hand. A related group is seen at the bottom of the left pilaster of *The Gates of Hell,* reversed and in low relief. In a second version of the detached group, the cavern has been eliminated and the child sits on the mother's left knee; in yet another, called *Fleeting Love,* he seems to be flying past the woman.

18. The Martyr

1885. Bronze, 18 x 59 x 38 in.

The Martyr was originally intended by Rodin to be attached by its back to the bottom of the left panel of *The Gates of Hell.* It can still be seen there, swathed in drapery, with eyes covered, wings added, and holding a wheel, beneath the groups of *Paolo and Francesca* and *Ugolino and His Sons.* When, however, Rodin decided to cast the figure as a separate work, he retained a section of the panel and used this as its base. Now, lying on its back in a deathlike position, *The Martyr* seems to have fallen from a great height.

19. Meditation

1885. Bronze, 29 x 11 x 11 in.

Meditation is based on the female figure standing in the crowd at the far right of the tympanum of *The Gates of*

Hell, with her left hand at her side away from her body and her right hand pushing back her hair. Rodin separated this figure from the *Gates,* enlarged it, and changed the position of the arms so that the left hand clasps the breast, and the head droops forward on the right forearm. Later he used modified and enlarged versions of *Meditation* in projects for the first monument to Victor Hugo. In one of these, known as *The Inner Voice,* both arms are raised over the head and the hands touch. In another version, the figure is badly mutilated, lacking both arms and knees; this was detached and exhibited as a separate sculpture.

20. The Centauress

By 1887. Bronze, 18⅛ x 17 x 5⅞ in.

The mythological centaur was of particular significance to Rodin since its dual nature seemed to him to represent man's supreme effort to escape from bestiality. He constructed *The Centauress* from the body of the horse used in the project for an equestrian monument to General Lynch (1886) and from a torso closely related to that of Paolo in *Paolo and Francesca* and that of *The Prodigal Son.*

21. Head of St. John the Baptist on a Platter

1887. Bronze, 7½ x 14½ x 10½ in.

Some years after making his life-size figure of *St. John the Baptist Preaching,* Rodin treated a later episode, the beheading of the saint. In this version, the severed head

rests on its side on a large tray, while in another, the head rests on its back. It is the latter that can be seen near the top of the buttresslike form on the right side of the *Gates.*

22. The Sirens

By 1888
[a] *Bronze, 17¾ x 17¼ x 10½ in.*
[b] *Plaster, 19½ x 17 x 10 in.*

Known also as *The Nereids* and *The Song of the Sirens,* this group depicts the sea nymphs who charm those who hear their extraordinary song. They can be seen, greatly reduced in scale, halfway up the left panel of *The Gates of Hell.* Rodin later proposed using *The Sirens,* enlarged and seen from behind, in the second project of the second Victor Hugo monument (c. 1892) to represent the voices of the sea which inspire the writer (see no. 63).

23. Polyphemus, Acis, and Galatea

1888. Plaster, 11⅝ x 6¾ x 8¾ in.

24. Polyphemus

1888. Plaster, 9¾ x 6 x 5¾ in.

This group, representing the story of the cyclops Polyphemus, who, deeply in love with the nymph Galatea, kills her lover Acis, was intended for *The Gates of Hell.* However, when it was inserted above the center of the right panel, the figures of Acis and Galatea were omitted, leaving only the figure of Polyphemus, but in duplicate. Both the group and the lone Polyphemus were later

exhibited as separate works. The figure of *Polyphemus* has been given other titles that are equally appropriate: as *Narcissus,* he can be seen as the fabled youth admiring his own reflection in the water; as *Milo of Croton,* he appears as the athlete who, despite his famed strength, was held fast in the grasp of a tree.

25. Shame (Absolution)

1889–90. Bronze, 25¾ x 15 x 12½ in.

The nature of the enigmatic encounter depicted by this group is only hinted at by the titles engraved in the base. The only known cast of this work, it is an assemblage of parts used in, or intended for use in, *The Gates of Hell.* To the torso of a seated adolescent girl has been added a head used as one of many small masks above the tympanum in the *Gates.* On her knees is balanced the figure of another adolescent girl, the *Andromeda,* as represented by the marble in this collection (no. 34).

26. Youth Triumphant

1894. Bronze, 20½ x 16½ x 12 in.

In this group an old woman, the figure of *The Helmet-Maker's Wife* (no. 6), holds on her lap a young girl whom she is kissing. The ambiguous relationship between the two figures has given rise to numerous interpretations. In spite of its macabre quality, this is one of the first works which Rodin had edited commercially on a large scale. Its commercial nature and the fact that the bronze was probably cast from a marble account for the lifeless quality of the modeling.

27. Decorative Pilaster from "The Gates of Hell"

BOTTOM SECTION

c. 1900. Bronze, 10⅞ x 2⅝ x ⅞ in.

28. Decorative Pilaster from "The Gates of Hell"

TOP SECTION

c. 1900. Bronze, 4¾ x 2⅛ x ¾ in.

These two fragments are reductions of parts of the left decorative pilaster of *The Gates of Hell,* on which are represented souls in Limbo. The reductions were made from the full-scale pilaster as it was about 1900, when it had been stripped of all the most protruding elements. A number of the figures have been completely removed, while several of those that remain have limbs missing.

SMALL GROUPS AND FIGURES

29. Medea

1865–70. Plaster, 23½ x 12½ x 9½ in

In the earlier catalogue of the Rodin Museum, this plaster was described as a Madonna. However, from the position of the headless figure, there is no doubt that this work is a study for *Medea Killing Her Children.* It is not surprising that Rodin, with his long fascination with the story of Ugolino devouring his sons, should make a sculpture of Ugolino's classical counterpart, Medea. He

was probably influenced by a painting by Delacroix of the same subject.

30. Despairing Man

1880–85. Plaster, 12½ x 21½ x 15½ in.

Although little is known of this handsome figure, it is probably one of the number of despairing figures done in the mid 1880s, when Rodin was working most intensively on *The Gates of Hell*. In pose and feeling, it can be compared with the better-known *Danaïd* and the *Andromeda* in this collection (no. 34).

31. Eternal Springtime

1884
[a] *Bronze, 25½ x 31½ x 15½ in.*
[b] *Plaster, 26 x 27⅝ x 16⅝ in.*

The commission for *The Gates of Hell* in 1880 gave Rodin much greater opportunity for imaginative expression than was previously at his disposal. It allowed him to create works on a smaller scale with all the intensity of his earlier, larger pieces. The subject matter of these small works became more serious, with love treated in human rather than allegorical terms. *Eternal Springtime* is one of the most lyrical works dealing with human love. To create this popular group, he took an already existing female figure, that of the *Torso of Adèle* (used on the top left corner of the tympanum of the *Gates)* and combined it with a male figure. Both the outstretched arm and overhanging leg of the man in the plaster version were later altered by the addition of the extensive base

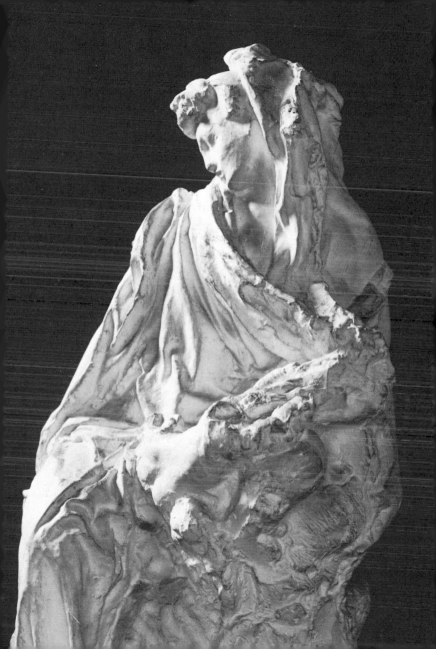

and the floral support, which facilitated the making of marble replicas and other bronze casts.

32. Fording the Stream

Before 1885. Plaster, 12 x 7 x 4 in.

The theme of this work — a muscular man carrying off a female — appears many times in *The Gates of Hell,* on the pilasters and the panels. This particular group does not appear on the *Gates,* although it seems probable that it may have been Rodin's intention to place it there at one time.

33. The Zoubaloff Fauness

1885. Bronze, 7⅛ x 4 x 6½ in.

Known by the name of the renowned nineteenth-century collector, Jacques Zoubaloff, who once owned the plaster of this work, *The Zoubaloff Fauness* is certainly one of Rodin's most provocative mythological subjects. It depicts a young woman chewing her long hair as she rocks back on her haunches, and was created by joining furry legs with cloven hooves to the upper part of a female body.

34. Andromeda

1885. Marble, 11¾ x 11½ x 9 in.

According to Greek myth, the oracle instructed Cepheus, king of the Ethiopians, to expose his daughter Andromeda to the sea monster to stop him from ravaging the kingdom. So that the monster could find her easily, Androm-

eda was chained fast to a rock on the coast. It is this moment in the story that Rodin represents, the moment before Andromeda was discovered by Perseus, who on condition that she marry him, slew the monster and rescued her. The figure of *Andromeda* is also used as the figure balanced on the knees of the seated girl in *Shame* (no. 25).

35. Eve and the Serpent

c. 1885. Plaster, 10⅝ x 5½ x 5 in.

The forms of this small plaster, also known as *Eve by the Apple Tree,* are inextricably confused. As is often the case in Rodin's work, the elusiveness of the group has given rise to a number of titles and, hence, interpretations. Thus it has also been suggested that Rodin may have had in mind the scene from Flaubert's *Salammbô* in which Salammbô unites herself with the Genius of the family before leaving the palace of Hamilcar.

36. Damned Women

c. 1885. Plaster, 8⅛ x 11¼ x 5 in.

So great was Rodin's admiration of feminine beauty that he was fascinated by women of every conceivable emotional disposition. The models for this group, inspired by Baudelaire's poem, "Femmes Damnées," and for a number of other works were two Lesbian dancers from the Opéra. Rodin's interest in this theme paralleled that of other nineteenth-century artists, including Courbet and Degas.

37. The Minotaur

c. 1886. Plaster, 13½ x 9½ x 8 in.

This plaster, also known as *Faun and Nymph* and *Jupiter Taurus,* is one of many works in Rodin's oeuvre inspired by the world of Ovid. Entitled *The Minotaur,* as Rodin preferred, the group represents the half-man, half-bull offspring of Pasiphaë and the bull, with one of its unwilling victims.

38. Sorrow No. 2

c. 1887. Plaster, 7¼ x 7⅞ x 3¼ in.

This is one of a group of works depicting grief, despair, and hopelessness that Rodin executed in the mid 1880s (see nos. 30, 34). It seems probable that at one time Rodin may have considered including this figure in *The Gates of Hell* but that he later changed his mind.

39. The Death of Adonis

By 1888. Plaster, 5⅞ x 10⅝ x 5¾ in.

This is another work in which Rodin drew on the world of Ovid for inspiration. Venus, in her devotion to Adonis, cautioned him against hunting dangerous animals, but ignoring her warning, he gave chase to a wild boar and was mortally wounded. Here Venus is shown mourning over the lifeless body of Adonis. This is a composite work formed from two female figures which are closely related to, but not identical with, many figures in *The Gates of Hell.* In another work Rodin represented a later episode in the myth, *The Resurrection of Adonis.*

40. Possession

c. 1888. Plaster, 9¼ x 4¾ x 4½ in.

These entwined figures are similar in feeling to those made by Rodin for *The Gates of Hell*. In this ferocious coupling, the male figure seems to be an unwilling participant. A smaller plaster of the same subject also exists, as well as two related plasters known as *The Sin* and *The Sin No. 2*.

41. Seated Figure

Early 1890s? Plaster, 7½ x 9¾ x 7½ in.

About 1890–91 Rodin, using as models dancers from popular dance halls, made a number of studies of the nude figure in very daring positions, including *Iris, Messenger of the Gods; Flying Figure; Crouching Woman* (London, Tate Gallery); and this seated figure. Its head, although greatly reduced in scale, is identical with that of the *Crouching Woman*. The entire figure, placed on its back with legs in the air, was used in the work known as *Ecclesiastes* (no. 46).

42. The Benedictions

1894. Bronze, 31½ x 23¼ x 25 in.

Although Rodin was by no means a socialist, he did believe strongly in the redeeming virtues of work. He designed these two figures to crown a colossal *Monument to Labor,* on which he worked during the last decade of the nineteenth century, but which was never constructed. His design, based on the famous staircase

of the Château of Blois, combined architecture with sculpture by having bas-reliefs, depicting many kinds of manual labor, wind up a tall central column surrounded by a staircase. At the summit were to be these two winged Genii blessing the laboring multitudes.

43. The Sorceress

1895. Bronze, 11⅞ x 11¾ x 6 in.

Very little is known about this work, and there is no connection between it and any known project. It may be that the rather malevolent-looking creature is participating in a witches' Sabbath.

44. The Hero

c. 1896. Bronze, 16 x 7 x 6½ in.

45. The Poet and Love

c. 1896. Plaster, 16¾ x 11 x 6 in.

The figures in these two works, and in a third, the *Project for a Monument to Eugène Carrière* (no. 69), are basically the same. They are a particularly striking example of Rodin's ability to manipulate the meaning of a figure by making slight adjustments, both in the figure itself and in its context. In *The Hero,* a winged female without head and arms seems to be on the point of moving away from the male, whose features are very generalized. This was described in the catalogue of the Rodin retrospective exhibition of 1900 as follows: "The young, vigorous hero, leaning on a rock, tries to hold back a Victory, a small winged figure of a capricious woman, ready to fly away."

The Poet and Love has a more tragic feeling. Both figures are conceived in high relief, and the winged female tries to escape from the poet's grasp with even more urgency. Roughly modeled outstretched arms have been attached to both figures. The head of the poet is that of the reduced version of the *Head of St. John the Baptist on a Platter* (compare no. 21). In the *Project for a Monument to Eugène Carrière*, the head of the male figure is that of a charming young man, and the winged female, hovering protectively above, holds a laurel wreath in her left hand.

46. Ecclesiastes

Before 1898. Plaster, 10 x 11 x 10 in.

Many of Rodin's groups were formed by juxtaposing figures that originally had no connection with one another. As an extension of this technique, he took great delight in confronting his figures with totally unrelated objects. *Ecclesiates* is one of the most surprising of these assemblages. A seated figure (no. 41) is placed on its back on a plaster cast of a real book.

47. Evil Spirits

1899. Bronze, 12¾ x 7⅞ x 9 in.

Evil Spirits is another of Rodin's groups composed of figures originally conceived separately. One of the two youthful forms hovering above the young girl was used in *The Gates of Hell*, while the figure of the seated girl was exhibited separately as *Woman Combing Her Hair*, a title applied on occasion to the entire group.

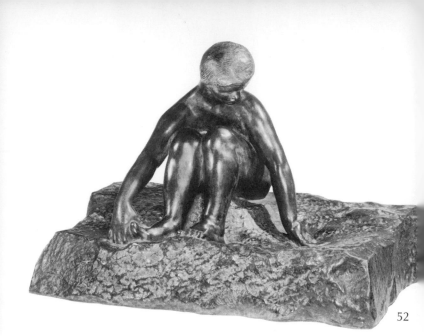

48. The Good Spirit

c. 1900. Plaster, 9½ x 5¼ x 5 in.

This group is another assemblage of pre-existing figures. Since it was necessary to increase the height of the figure of the kneeling woman in order to adapt it to that of the young girl, Rodin simply placed the upper torso of another female figure on top of the torso of the kneeling woman, with the result that the new figure had two pairs of breasts. The new form suggested to Rodin the title of *Young Girl Confiding Her Secret to Ceres*, but it is now generally known as *The Good Spirit*.

49. The Athlete

1901–4. Bronze, 16⅞ x 12½ x 11¼ in.

Always an admirer of masculine muscular development, Rodin took as a model in 1901 and again in 1904 a young American, Samuel Stockton White, 3rd, of Germantown, Pennsylvania, who while studying at the University of Cambridge had become the protégé of the strong man Eugene Sandow. In recompense for his services, Rodin gave White the first cast of another version of this work, in which the head looks straight ahead (now in the Samuel S. White, 3rd, and Vera White Collection in the Philadelphia Museum of Art). The Museum's bronze differs from that of the White Collection in the greater degree of finish and in the position of the head, which is turned to the left.

50. Exhortation

1903. Plaster, 15¾ x 12½ x 14¾ in.

This is yet another assemblage of figures that originally existed independently; like *The Benedictions* (no. 42), which it closely resembles in both movement and feeling, it may have been intended to crown a monument.

51. The Fish Woman

1906. Plaster, 13 x 17 x 10 in.

As a young man Rodin was forced by his precarious financial position to produce a large amount of frankly decorative sculpture, much of which he later discarded. However, after 1900, when he was no longer in dire

need of funds, he voluntarily returned to this decorative form with enthusiasm. Among these late pieces was *The Fish Woman,* who, appearing to be coming up for air, was clearly intended to form part of a fountain.

52. Beside the Sea

c. 1907. Bronze, 22⅝ x 33 x 22½ in.

Beside the Sea belongs to the group of later works in which Rodin sought to recapture the serenity that he admired so much in ancient art. There is a surprising resemblance in this figure to the work of Maillol, who was also profoundly influenced by the earlier phases of Greek art about this time.

53. Nude Woman (Galatea)

1909. Bronze, 14½ x 9 x 6 in.

Nude Woman is almost identical to the female figure in *Pygmalion and Galatea,* which represents the moment when the statue on which Pygmalion has been working comes to life under his hands. This work may thus be thought of as the study of a sculpture that has just come to life.

54. Oceanides

Before 1910. Bronze, 20½ x 29½ x 18 in.

Toward 1910 Rodin's increased interest in pagan themes resulted in a group of works based on the diversions, amatory and playful, of mythological figures. One of these, *Oceanides,* represents a group of sea nymphs; it consists of three female figures, two of whom are

crouching while the third hovers above them. The figures, all previously used in other works, emerge only partially from the rocky background. This bronze was cast from the original marble.

55. Bacchus in the Vat

1912. Bronze, 23⅞ x 16½ x 17 in.

This work, like *Ecclesiastes* (no. 46), is an example of Rodin's use of the juxtaposition of one of his sculptures, or a fragment of a sculpture, with an inanimate object. *Bacchus in the Vat* shows the laughing figure of the god of wine falling backward into a wine-filled vat.

MAJOR WORKS

56. The Age of Bronze

1875–76. Bronze, 67 x 23⅝ x 23⅝ in.

The Age of Bronze, also known as *The Vanquished* and *Man Awakening to Nature*, was modeled by Rodin during the latter part of his stay in Brussels. He commenced work on the figure in the middle of 1875 and finished it in December, 1876. At first, when it was still called *The Vanquished*, the figure held a spear in its left hand, but this was eliminated before it was exhibited. In this work, Rodin strove with diligence and intensity to create as faithful a reproduction as possible of the body of the young Belgian soldier, Auguste Neyt, who was his model.

He succeeded so well in accomplishing his aim, in fact, that when the statue was exhibited, he was accused of having assembled it from casts taken directly from the model. It was only after tremendous difficulty that he was able to disprove the charges of life-casting. In spite of the accusations, *The Age of Bronze* rapidly became one of Rodin's most popular works, with well over forty casts of the life-size figure having been made.

57. St. John the Baptist Preaching

1878. Bronze, 79 x 21 3/4 x 38 1/2 in.

The accusations leveled at Rodin in connection with *The Age of Bronze* made him decide to make his next major figure, *St. John the Baptist Preaching,* somewhat larger than life size. He chose St. John for his subject, not because it was popular with Salon sculptors, but because, late in 1877 or early in 1878, an Italian peasant appeared in his studio seeking work as a model. The man had never posed before, but his appearance of great physical strength and mystical power so forcefully reminded Rodin of the characteristics of St. John the Baptist that he felt he must use the peasant as a model for a figure of the saint. When asked to walk and pose, the man instinctively took a determined stance. Although clumsy by conventional standards, the pose struck Rodin as being particularly appropriate for a figure of the Forerunner. Toward the end of the nineteenth century, Rodin returned to his preliminary studies for *St. John the Baptist Preaching* for his figure known as *The Walking Man.*

With the Italian as his model, Rodin made a conscious effort to create a convincingly realistic image of the

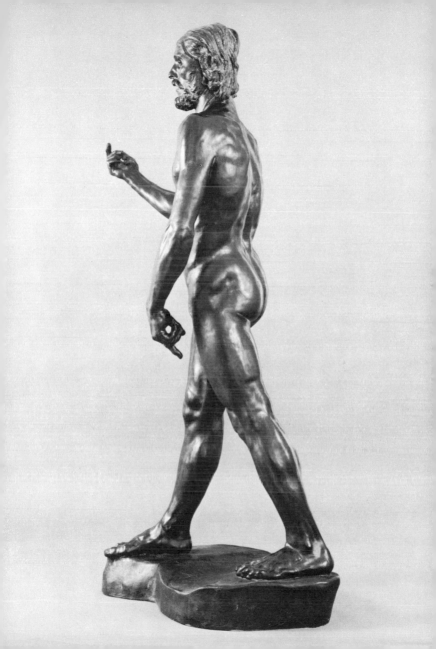

historical St. John the Baptist. At first he provided the figure with an identifying attribute, a cross supported against the left shoulder, but by the time the sculpture was exhibited at the Salon of 1880, the cross had been removed, since the power of the figure made such details unnecessary and distracting.

While working on the figure of the saint, Rodin evolved his theory of movement. He decided that sculpture should not "stop the clock," but should represent a sequence of movements in one figure. Thus by placing the two feet firmly on the ground instead of raising one, as would have been evident in a photograph, Rodin was able to suggest consecutive movements required to take a step. Another of Rodin's practices which developed from this work was that of allowing the model to dictate the pose. From this time on, he encouraged his models to move freely about the studio so that he could catch their fleeting, natural movements. He thus made a complete break with the academic tradition of fixed poses.

58. The Call to Arms

1879. Bronze, 43½ x 22½ x 15 in.

Competitions for two monuments, one to commemorate the defense of Paris in the Franco-Prussian War, the other to honor the Republic, were organized in 1879. To the former Rodin submitted the group known as *The Call to Arms* or *The Defense;* to the latter he submitted the work later known as *Bellona* (no. 99). The composition of *The Call to Arms* shows a falling wounded soldier supported by his sword, looking up at a spirited allegorical figure of the Genius of War. Although the

project received no award, Rodin maintained his interest in it. Thirty-three years later he supervised the enlargement of the group from its original size to 92¾ inches in height, and four years later made another enlargement, twice the size of the latter. This was commissioned by the Dutch committee formed to honor the City of Verdun, where it was erected August 1, 1920.

59. The Burghers of Calais

1884–95. Bronze, 82½ x 94 x 75 in.

60. Small Head of Pierre de Wiessant

1886. Bronze, 4¼ x 3 x 3¼ in.

61. Assemblage of Heads of "The Burghers of Calais"

Late 1880s? Plaster, 9½ x 11 x 9¼ in.

In 1884 Rodin was commissioned by the City of Calais to make a monument to the celebrated burghers who saved the city from the English in 1347. According to the fourteenth-century *Chronicles* of Froissart, Rodin's main source of information, King Edward III offered to lift the English siege of Calais if six burghers, wearing sackcloth and carrying the keys of the city, would present themselves at his camp as hostages. Led by Eustache de Saint Pierre, six of the most prominent citizens left for the English camp, but later, at the request of Queen Philippa, they were allowed to go free.

Rodin began work on this complex, heroic subject in 1884. Using as his models middle-aged men of pronounced character, he modeled each figure in the nude

before clothing it. His aim was to represent as movingly as possible the reactions of the individual burghers to the tragic events in which they were involved, ranging from the stoic resignation of Eustache de Saint-Pierre (the old, bearded figure standing in the middle of the group) to the unrelieved despair of Andrieu d'Andres (the figure holding his head in his hands at the far right). Rodin then experimented with various groupings of the six figures, lining them up in two rows before deciding on the circular arrangement of the finished monument.

Rodin wanted his group to be placed in the center of a city square either at ground level or on a high pedestal,

59 (detail)

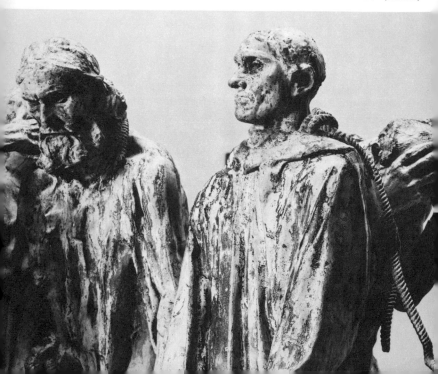

but when it was erected in Calais in 1895, it was placed on a pedestal of medium height, much to his displeasure. Finally, in 1924, *The Burghers of Calais* was moved to a low pedestal in front of the rebuilt City Hall of Calais. In addition to the Museum's cast, there are now seven others, in Basel, Brussels, Copenhagen, Calais, London, Tokyo, and Greenwich, Conn. (Collection of Joseph H. Hirshhorn).

The *Assemblage of Heads of "The Burghers of Calais"* is one of Rodin's most surprising and proto-surrealist assemblages. Three pairs of heads and a variety of hands are placed pell-mell on a plaster platform. The expression of grief is overwhelming. Over the fragments hovers a winged angel, taken from *The Gates of Hell;* knowledge of its origin makes its presence less than reassuring.

62. Project for a Monument to Claude Lorrain

1889. Bronze, 48½ x 17 x 20¾ in.

On April 9, 1889, Rodin's project for a monument to Claude Lorrain to be erected in the city of Nancy was chosen from among the twelve submitted. In his work, Rodin showed the figure of "the painter of light" placed on a pedestal from which emerged Apollo and the Chariot of the Sun, as is seen here. When the monument was finally unveiled in Nancy in 1892, it met with so much hostile criticism that Rodin felt obliged to make some of the suggested changes, including alterations to the group of Apollo and the horses. Later, he bitterly regretted these modifications.

63. Apotheosis of Victor Hugo

1890–91. Bronze, 44 x 20¼ x 24 in.

In 1889 Rodin was commissioned to make a monument in honor of the greatly admired writer Victor Hugo as part of the sculptural redecoration of the Panthéon in Paris. In the projects for this monument, Rodin showed the poet nude, seated on a rock, surrounded by muses. In 1890, however, the commissioning body decided that none of these projects was suitable for the proposed location. They then authorized Rodin to proceed with the execution of this work for the Luxembourg Gardens and commissioned a second monument for the Panthéon. Rodin described the first project for this second monument in a letter, saying that the figure of Hugo, who is being crowned by two muses, is seen standing on a rock against which waves are beating; a woman in the water brings Hugo a lyre while a powerful figure representing the People contemplates him from below. Behind the monument the figure of Envy flees into a cavity. It is this stage in the development of the monument that the Museum's bronze represents, differing from the foregoing description only in certain details, notably the presentation of the symbolic figures. Rodin worked simultaneously on both monuments. A greatly simplified version of the first monument, representing Victor Hugo seated alone on a rock, was unveiled, not in the location for which it was intended but in the gardens of the Palais Royal, in 1909. A rough model of the second project of the second monument representing a naked, walking figure of Hugo being crowned by two muses, with an enlarged version of *The Sirens* (no. 22) at the writer's

feet, was approved by the committee in 1892. As late as 1914, Rodin promised to deliver this monument within two years but the war and his declining health prevented its completion.

64. Balzac in a Frock Coat, Leaning Against a Pile of Books

1891–92. Plaster, 23⅝ x 9½ x 11¾ in.

65. Head of Balzac

1891–92. Plaster, 6¼ x 8¼ x 4½ in.

66. Balzac

1897. Bronze, 41¾ x 15¾ x 13¾ in.

67. Colossal Head of Balzac

1897. Bronze, 20 x 16½ x 15¼ in.

Starting in 1851, a year after Balzac's death, several attempts had been made to erect a monument to the great writer of the *Comédie humaine*, but they had all ended in failure. In 1888 the sculptor Henri Chapu was chosen for the task but he died in 1891, before the completion of his work. That same year, largely through the agency of Emile Zola, Rodin received the commission for the monument. As was his custom, Rodin not only made a thorough study of his subject, reading all the available literature, but, working from documents, portraits, and photographs and using as models men of similar physical build, he made a considerable number of studies. There are studies of the head alone and of the entire figure,

both clothed and unclothed; in all of them, Rodin was attempting not only to create a physical resemblance to the writer but to capture the essence of his genius. Wanting to avoid what he referred to as "photography in sculpture," he exaggerated and synthesized the physical facts so as to achieve a symbolic representation of the famed writer's genius. The penultimate and final versions of the monument show Balzac standing draped in a robe, with hair tossed like a lion's mane, deep-set eyes under protruding eyebrows, a huge, beaklike nose, and an undefinable smile on the accentuated lips.

The exhibition of the *Monument to Balzac* at the Salon de la Société Nationale in 1898 gave rise to a violent political scandal. The Société des Gens de Lettres, which had commissioned the monument, refused to accept it on the grounds that it was unfinished and that Balzac could not be recognized in it. Rodin thereupon withdrew the work from the Salon and, in spite of many offers of purchase, took it to his studio at Meudon. Finally, in 1939, the Société des Gens de Lettres relented and the *Monument to Balzac* was erected in a public position in Paris, at the junction of the boulevards Raspail and Montparnasse.

The plaster study (no. 64) is one of the earliest studies for the monument. It shows Balzac in contemporary dress, leaning against a pile of books in his study. The plaster head (no. 65) consists of the head and shoulders of the famous figure of the *Naked Balzac,* which dates from 1891–92. The penultimate version of the draped figure (no. 66) differs from the final version only in the head, which is turned more sharply to the left, and in the greater angularity of the draperies. The colossal head

65

(no. 67) is an enlargement of the head of the final version.

A small plaster figure (not numbered) showing a seal posed as Balzac and inscribed "Un pas en avant" ("One Foot Forward") is a caricature of the *Monument to Balzac* that was sold as a souvenir at the time of the exhibition of the sculpture at the Salon in 1898. It is not known by whom it was made or sold. The fact that it was made at all, however, is a measure of the extraordinary notoriety surrounding the work.

68. President Sarmiento

1894–96. Bronze, 43 x 23 x 18 in.

In 1894 a committee in Buenos Aires commissioned Rodin to make a monument in honor of Domingo Faustino Sarmiento (1811–1888), who had been one of the most remarkable men in the history of nineteenth-century Argentina. Known as an educator, author, and statesman, Sarmiento served for six years as President of Argentina. Working from photographs, Rodin composed a monument depicting Sarmiento striding forward at the top of a high pedestal on which Apollo, vanquisher of the snake of error and ignorance, is shown. The figure of the President was completed by 1896 although the monument was not inaugurated in Buenos Aires until 1900 when, like so many others, it received much unfavorable criticism. The Museum's bronze is the final study for the over-life-size figure in the monument.

69. Project for a Monument to Eugène Carrière

1912. Plaster, 16 x 7 x 7¾ in.

A strong feeling of mutual admiration existed between Rodin and Eugène Carrière (1849–1906), whose work, in fact, exerted a considerable influence on Rodin's later style. In 1912, when he was asked by a committee to make a monument to his deceased friend, Rodin returned to a configuration which he had used earlier (nos. 44, 45) but made slight changes which greatly altered the mood of the work. Unfortunately the monument was never erected.

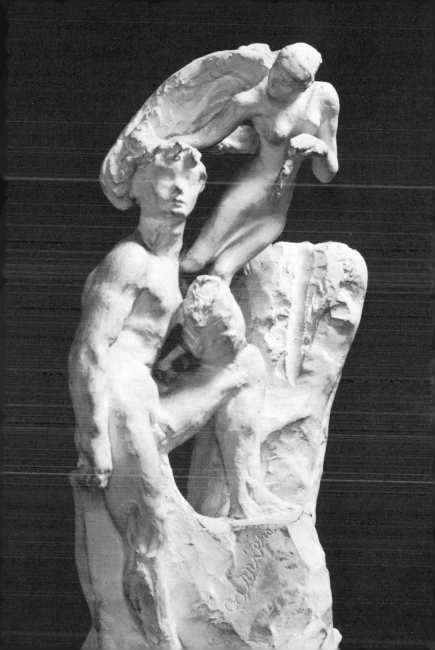

PORTRAITS

70. Father Pierre-Julien Eymard

1863
[a] *Bronze, 5½ x 4 x 4⅝ in.*
[b] *Bronze, 22¾ x 11 x 10½ in.*

Father Pierre-Julien Eymard (1811–1868), who was canonized in 1962, was the founder of the Society of the Blessed Sacrament. It was in this religious order that Rodin sought refuge following the death of his sister Maria in 1862. As Brother Augustin, Rodin modeled the bust of Father Eymard, which so impressed him that he persuaded Rodin to return to the world and become a sculptor. Its severe forms, smooth surfaces, and blank eyes show the classical bent of Rodin's early style. Two casts of this work are in the Museum, one showing the head alone and the other, considerably enlarged, showing the entire bust.

71. Mask of the Man with the Broken Nose

1863–64. Bronze, 10¼ x 6⅞ x 9¾ in.

On leaving the Society of the Blessed Sacrament, Rodin, unable to afford a studio, rented a drafty stable in a working-class quarter of Paris. There, he modeled the head of *The Man with the Broken Nose,* using as his model a handyman by the name of Bibi, whose battered features particularly impressed him. He made a very thorough study of all the contours of the head, but on

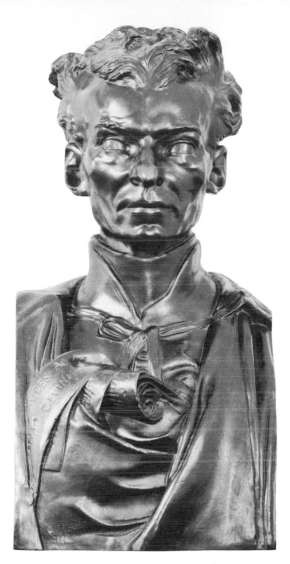

70b

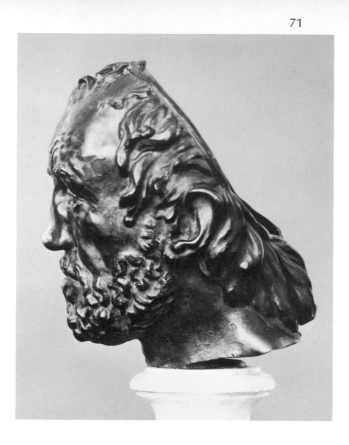

a cold winter night, the clay froze and the back of the head fell off, leaving only the face. Although slow to gain popular favor, this mask later became widely celebrated and exists in many casts and versions. Rodin later referred to it as his first serious piece of modeling.

72. Mignon

1867–68. Bronze, 15½ x 12 x 9½ in.

73. Mask of Mme Rodin

1880 (executed 1911)
Pâte de verre, 9½ x 6¼ x 7⅛ in.

Rose Beuret, a simple and illiterate girl, met Rodin in 1864 and, although extremely jealous of his many liaisons, lived with him for the rest of her life. She did not marry him until January 29, 1917, sixteen days before her death. During their life together, Rodin often used Rose as his model, and also made several portrait busts of her. The first of these is the one generally called *Mignon,* which shows great vivacity and almost baroque rhythms. Rodin modeled two later portraits of her, *L'Alsacienne* and the *Mask of Mme Rodin,* but none after she reached the age of forty. Instead he returned, in both marble and *pâte de verre* (ground-glass paste), to earlier images of her made in happier times. *Mignon* represents Rose Beuret at the age of twenty-five or twenty-six, while the mask, made in 1911 from the mask of 1880, represents her when she was nearly forty.

74. Bust of an Unknown Man

1880. Terra cotta, 20½ x 8½ x 8½ in.

The sitter for this bust was identified by Grappe (*Catalogue du Musée Rodin,* Paris, 1944, no. 126) as Henry Thorion, a prominent personality in Nancy, whom Rodin was assumed to have met during the 1880s when he was working there on the *Monument to Claude Lorrain* (no.

62). However, since the date 1880 is inscribed on the base of this sculpture, this identification seems improbable, and the bust must be described as the portrait of an unknown man. It is among the first of the powerful group of portraits done by Rodin during the decade of the 1880s.

75. Jean-Paul Laurens

1881. Bronze, 22¾ x 14¾ x 13 in.

Rodin and Jean-Paul Laurens (1838–1921), the French painter of historical subjects, had the highest regard for one another. After Rodin executed this spirited bust of the painter in 1881, Laurens painted a portrait of the sculptor. Laurens wrote one of the eulogies for the catalogue of the important exhibition of Rodin's works in 1900. Comparison of this bust with that of Carrier-Belleuse (no. 77), made about the same time, shows how Rodin adapted his style to the status of his sitter. The bust of Carrier-Belleuse is relatively informal, whereas Laurens has a formality in keeping with the public position of history painter.

76. Alphonse Legros

1881–82. Bronze, 12¼ x 7¾ x 9 in.

Alphonse Legros (1837–1911) and Rodin became friends about 1854, when they were students at the "Petite Ecole." They were both profoundly affected by the technique of drawing from memory taught by Horace Lecoq de Boisbaudran, although in diverse ways. In 1863 Legros settled in England, where in 1875 he became Professor

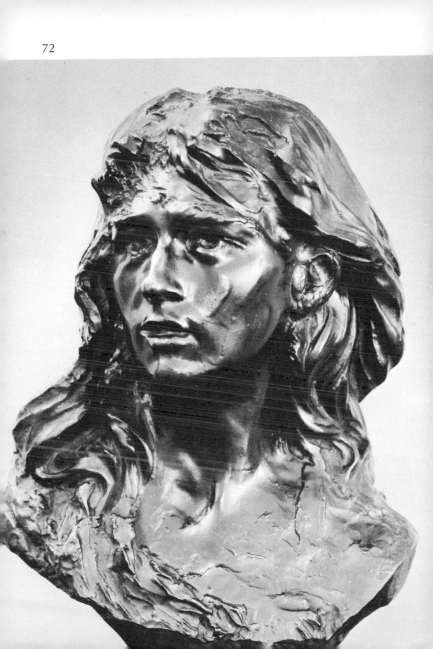

of Engraving at the South Kensington School and the following year, Director of the Slade School of Art. He retained this post until 1893, teaching actively although he never learned to speak English. In 1881 at the invitation of Legros, Rodin made his first visit to England. There he met a number of influential men who later were to become his active supporters. Rodin began the bust of Legros while in England, finishing it when he returned to France, in return for which Legros painted Rodin's portrait and also made an engraving of him. Much later Rodin helped to rescue Legros' reputation from oblivion in France by bringing his work to the attention of French critics and connoisseurs.

77. Albert-Ernest Carrier-Belleuse

1882 (executed 1907)
Biscuit de Sèvres, 14½ x 9½ x 5½ in.

Albert-Ernest Carrier-Belleuse (1824–1887) was the most fashionable and productive sculptor of the Second Empire. Rodin began to work for him in 1864 and followed him to Brussels in 1871 after serving in the National Guard during the Franco-Prussian War. Their working arrangement was terminated after a disagreement that arose when Carrier-Belleuse saw a work in a shop window which Rodin had modeled and offered for sale on his own behalf. But after Carrier-Belleuse became director of the Sèvres porcelain factory, Rodin worked for him again intermittently from 1879 to 1882. Working for this fashionable and sometimes superficial sculptor was important for Rodin. He was not only relieved of the more menial tasks he had previously been forced to do, but

had the occasion to learn how a large and important atelier was organized. Seeing that in large-scale production many assistants were required, Rodin realized that the artist himself need not be responsible for the execution of a work from beginning to end. Later, in reaction against his former employer for whom he had mostly modeled draped figures, he turned to the almost exclusive modeling of the nude. The bust, conceived in 1882, was first exhibited in a life-size version in terra cotta. This version is a reduction that was issued in *biscuit de Sèvres* (unglazed porcelain) by the Sevres factory.

78. Jules Dalou

1883. Bronze, 20¾ x 16 x 7 in.

Jules Dalou (1838–1902) studied at the "Petite Ecole" just before Rodin became a student there. He then enrolled at the Ecole des Beaux-Arts but he spent little time there since he preferred to study the seventeenth- and eighteenth-century sculpture at Versailles. Real success came to him in 1870 when his *La Brodeuse* was shown at the Salon. At that time, having supported the Commune, he was forced to flee to England, where he was well received. Returning to France in 1879, he devoted his last years to monumental sculpture. Early in their careers, Dalou and Rodin met while working for the decorator Laouste and became close friends. Soon after Rodin completed the bust in 1883, the friendship was marred by a series of misunderstandings. Dalou turned from being Rodin's greatest admirer to being his severest critic, although the widening gulf between them was caused as much by artistic as by personal differences.

79. Victor Hugo

1883
[a] *Bronze, 17 x 10¼ x 10¾ in.*
[b] *Plaster, 22¼ x 10 x 11½ in.*

In 1883 Rodin asked the aging Victor Hugo (1802–1885), then at the peak of his fame, if he might make his portrait. Hugo agreed reluctantly, but on the condition that he did not have to pose. Accordingly, Rodin made many quick sketches while Hugo was dining and conversing with his friends, but had to work from memory on the bust itself. Rodin completed the bust six months before the writer's death, but it proved to be so displeasing to his family that Dalou was invited to make the death mask. Rodin made another colossal version of the bust in 1897 when he was working on the over-life-size standing figure of the poet.

80. Henri Becque

1883 (reduced 1907?)
Bronze, 6 x 3¼ x 2⅝ in.

Henri Becque (1837–1899), well-known as a playwright in Paris in the 1880s, was a close friend of Rodin. He sat for the sculptor in 1883. Rodin made a terra-cotta bust of him and shortly after, a drypoint showing Becque from three different views. A plaster enlargement made in 1907 served for the execution of the marble monument to Becque unveiled in 1908. It is probable that the Museum's bronze bust is a reduction of the original terra cotta and that it was executed at the same time as the plaster enlargement.

81. Mme Vicuña

1884. Bronze, 14¼ x 14 x 10 in.

Rodin, who began to mix in more fashionable society in the 1880s, used to meet Mme Luisa Lynch de Morla Vicuña, wife of the Chilean Ambassador, at the Chilean Embassy and at the various salons he frequented. A marble bust of Mme Vicuña, executed in 1884, immediately became extremely popular. In 1888, in fact, it was purchased by the French Government. It is probable that the Museum's bronze version was specially commissioned by Mr. Mastbaum since no other bronzes of this bust are known to exist.

82. Pierre Puvis de Chavannes

1890. Bronze, 16¼ x 6¾ x 9 in.

No painter had a greater reputation at the end of the nineteenth century than Pierre Puvis de Chavannes (1824–1898), who was principally active as a painter of large-scale decorative works. Rodin had the most sincere admiration for Puvis and made this bust of him in 1890. He first showed him in the antique style, with bare shoulders and chest, but later, at Puvis' request, he rapidly added the frock coat, wing collar, and the rosette of the Legion of Honor. Puvis did not like the portrait bust despite his admiration for Rodin and the high critical acclaim it received. In the Museum's bronze, the head is supported not by fully clothed shoulders as in the first exhibited version, but by a small, squarish base on which the line of the collar is barely visible.

83. Sévérine

1893. Bronze, 6⅜ x 4¾ x 5 in.

Sévérine was the nom de plume of Caroline Rémy (1855–1929), the novelist, lecturer, and journalist and a woman of advanced political opinions. During the 1890s she was one of Rodin's most spirited defenders in the press, and later gave one of the orations at his funeral. In the early 1890s Rodin made several fine drawings of Sévérine, evidently studies for this small bronze mask.

84. Countess Hélène von Nostitz Hindenburg

1902 (executed 1911)
Pâte de verre, 9 x 8¼ x 2⅝ in.

From the time they met at the International Exhibition of 1900, Rodin and Countess Hélène von Nostitz Hindenburg enjoyed a close friendship; they corresponded extensively, and Rodin made several visits to her home in Italy. Rodin modeled a small bust of the Countess in 1902, and later also a larger version, but it was to the early study that he returned in 1911 when he had it executed in *pâte de verre*.

85. Eugène Guillaume

1903. Bronze, 13 x 7 x 10 in.

Eugène Guillaume (1822–1905), who studied at the Ecole de Dessin and then at the Ecole des Beaux-Arts, became the most successful sculptor in France in the second half of the nineteenth century. Following his appointment

as Director of the Ecole des Beaux-Arts, he held all of the most important posts in the official Parisian art world. Although Rodin and Guillaume differed fundamentally in artistic outlook, they became close friends in their later years. Rodin showed his affection for the aged sculptor in this freely modeled bust, which he made shortly before Guillaume's death.

86. George Bernard Shaw

1906. Bronze, 15 x 7¼ x 8½ in.

Although the playwright and polemicist, George Bernard Shaw (1856–1950), generally refused to sit for his portrait, he willingly agreed to be a model for Rodin because he had such great admiration for the sculptor. Rodin was impressed by the peculiar features of the famous writer's head — the hair parted in two standing locks, the forked beard, the sneering mouth — being unable to decide whether he were more Christ-like or diabolic. To Mrs. Shaw, however, the portrait was such a striking likeness of her husband that she wrote a letter of congratulations about it to Rodin.

87. Marcelin Berthelot

1906. Plaster, 18 x 11 x 9 in.

Pierre-Eugène-Marcelin Berthelot (1827–1907) was one of the greatest scientists of the nineteenth century as well as an active participant in public affairs. Rodin, much interested in the scientific researches of Berthelot, made his bust in 1906. It seems that he wished to stress the great intellect of the man by returning to his earlier, more

classical style of modeling. It is certainly very different in style from the more spirited handling of many of the later busts.

88. Joseph Pulitzer

1907. Bronze, 19 x 18½ x 10 in.

Joseph Pulitzer (1847–1911) came to the United States from his native Hungary in 1864, embarking on a career of politics and journalism. His early dealings in newspapers enabled him to study law and eventually to become the owner of the *St. Louis Post-Dispatch* and then the New York *World*, which he made into one of the foremost liberal newspapers of his time. Always a controversial figure, Pulitzer continued to control newspaper policies even though illness and finally total blindness marred the last years of his life. He was already blind when he posed for Rodin in France in 1907. Although Pulitzer was a petulant sitter, Rodin was able to produce a very moving image of this powerful man.

89. Hanako

1908. Plaster, 6¾ x 4¾ x 4⅝ in.

90. Hanako

1908 (executed 1911)
Pâte de verre, 8⅝ x 4¾ x 3½ in.

Rodin was passionately interested in the dance, and was greatly impressed by the royal Cambodian ballet when it was brought to Paris in 1906 by the King of Cambodia. Shortly after, he was introduced to the Japanese dancer

Ohta Hisa (1868–1945), better known as Hanako, by the celebrated veil dancer Loïe Fuller. Rodin admired Hanako's strength and self-control, and modeled several heads of her which are unrivaled in their expression of intense emotion. The plaster mask dates from 1908 while the *pâte de verre* mask was made in 1911 (after another plaster of 1908) at the same time as the *Mask of Mme Rodin* (no. 73) and the portrait of *Countess Hélène von Nostitz Hindenburg* (no. 84).

91. Gustav Mahler

1909. Bronze, 13½ x 9 x 8¾ in.

On meeting the great Austrian composer and conductor, Gustav Mahler (1860–1911), in Paris during 1909, Rodin was deeply impressed by his noble features, saying that they were a mixture of those of Frederick the Great, Benjamin Franklin, and Mozart. The bust, made shortly after this meeting, is one of the finest and most moving of Rodin's late portraits. When the head was later carved in marble, it reminded Rodin so much of Mozart that it became known under that title.

92. Edward H. Harriman

1909. Bronze, 19¼ x 12 x 7¾ in.

Edward Henry Harriman (1848–1909) made his career as a reorganizer of bankrupt railroads, becoming president of the Illinois Central and the Union Pacific. He continued to buy shares in other companies, and his influence was exerted on a great many railways throughout the country. In addition, he was the owner of a line of

steamships and a director of the Equitable Life Assurance Society. Such strong and pervasive influence created a great deal of hostility to him. Georges Grappe *(Catalogue du Musée Rodin,* Paris, 1944, no. 394) stated that the bust of Harriman was executed posthumously from photographs, but it now seems likely that Harriman sat for Rodin during the last summer of his life while he was in Europe for medical treatment.

93. Barbey d'Aurevilly

1909–12. Bronze, 33½ x 27½ x 22¼ in.

The novelist and critic, Jules-Amédée Barbey d'Aurevilly (1808–1889), was one of the most celebrated dandies of his day. His clothes were one of the ways he showed his defiance of the growing industrialization and conformism of society. He wrote against the Church in several of his early novels but then he returned to Roman Catholicism. In his later years he was greatly admired as a fervent monarchist, traditionalist, and Catholic by younger writers of similar persuasions. In 1909 Rodin was asked to make a monument to the writer for the village of Saint-Sauveur-le-Vicomte, his birthplace in Normandy. In principle Rodin was opposed to making posthumous monuments, but after he was given a death mask and photographs of Barbey, he undertook to execute the monument, creating an astonishing image of the arrogant and aging dandy. This bronze is an enlargement of the bust made after the death mask, and is identical with the one that was erected in Saint-Sauveur-le-Vicomte.

94. Georges Clemenceau

1911. Bronze, 18½ x 13 x 10 in.

Georges Clemenceau (1841–1929) gave up an early career in medicine to enter politics. In 1889 he started the newspaper *La Justice,* which rapidly became the principal organ of Parisian radicalism. He became Premier of France as well as Minister of War during the Poincaré presidency in 1917, and from November, 1918, to June, 1919, devoted himself to the settlement of the war. The relationship between Rodin and Clemenceau became rather uneasy after Rodin refused to sign the petition which Clemenceau was organizing on behalf of Dreyfus. In 1911 Clemenceau agreed to sit for his portrait but his antagonism made it very difficult for Rodin to complete the bust. Rodin made over twenty-three studies but none proved satisfactory to Clemenceau, who complained that Rodin made him look like Genghis Khan.

95. Pope Benedict XV

1915. Bronze, 9½ x 6¾ x 9¾ in.

A group of Francophiles in the Vatican asked Rodin to make a bust of the ruling Pontiff, Benedict XV (1854–1922). For this purpose, Rodin went to Rome in 1914, but since sittings were impossible to arrange at that time, he returned the following year. On the second visit, the Pope granted Rodin only four sittings, with the result that the bust is unfinished. In spite of this, Rodin's head is outstanding among papal portraits for the intimacy of its approach and its ruthless portrayal of physical infirmities.

95

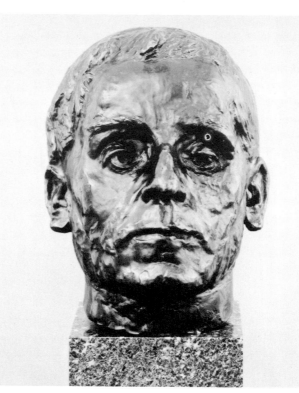

96. Etienne Clémentel

1916. Bronze, 20⅜ x 21⅝ x 11 in.

Etienne Clémentel (1864–1936), who was active in French
politics at the beginning of this century and the founding
President of the International Chamber of Commerce,

became close to Rodin when he was called in to take charge of the sculptor's affairs during the last years of his life. Because of Rodin's rapidly declining health, the sculpture remained unfinished. Nonetheless, this last bust, and the last work done by Rodin, compares favorably with the best of the portrait busts produced in the 1880s.

ALLEGORICAL PORTRAITS

97. Flora

1865–70. Terra cotta, 13¾ x 8 x 7¾ in.

Not surprisingly, when Rodin was young, his taste was relatively conventional. He scorned the Gothic, preferring instead the charm of Carrier-Belleuse and Carpeaux. His earliest portraits, which were of male subjects, followed the classicism of David d'Angers. His first female portraits, however, were of sitters chosen not for their character but for their girlish charm. *Flora,* along with other works done at this time, reflects the influence of the sculpture of eighteenth-century France to which Rodin had been exposed during his training at the "Petite Ecole."

98. La Lorraine

1872–75
Terra cotta (painted), 15¼ x 10½ x 8 in.

The dating of *La Lorraine* must remain speculative, although the date 1872–75 seems probable since the exe-

cution, with its smooth surfaces and detailed treatment of accessories, as well as the rather superficial charm, relate it to the frankly decorative sculpture of Carrier-Belleuse, whose style continued to influence Rodin in the early 1870s. It was also at this time that Rodin's financial needs forced him to create works of popular appeal which would be salable.

99. Bellona

1879. Bronze, 30½ x 22¾ x 14½ in.

This work was originally intended to represent the Republic, an extremely popular subject among French sculptors during this politically self-conscious age. It was submitted in a competition for a monument to the Republic organized by the City of Paris in 1879. Perhaps because of its origins in his own stormy life, Rodin's work has more fierce vitality than the versions of this subject made by his contemporaries. The belligerence of the baleful glance of this head, similar to that of the Genius of War in *The Call to Arms* (no. 58), was in fact inspired by Rose Beuret's countenance during one of their violent quarrels. Suggested, no doubt, by the fierce expression, the work soon received the title *Bellona*, by which it has since been known.

100. Thought

1886–89. Bronze, 17¾ x 15⅝ x 16½ in.

In this work, as in many others, Rodin used the features of Camille Claudel (1864–1943), the sister of the poet Paul Claudel. Rodin had met Camille in 1883, when at

the age of nineteen, she was studying art and sharing a studio in Paris with fellow students. A close friendship developed, and Camille became Rodin's constant companion for several years. This intimacy caused Rose Beuret much anxiety, because she realized that in Camille, Rodin found not only a beautiful woman, but a talented sculptress whose work he greatly admired. After four or five years, however, quarrels began, increasing in intensity until a complete break finally occurred. This break, shattering to Rodin, was catastrophic to Camille. She entered a life of total seclusion, and finally had to be removed forcibly to an asylum. During this time, Rodin did all he could to find buyers for her work, and to arouse interest in it.

It is difficult to date *Thought*. The first study seems to have been made in 1886; the marble enlargement (a version of which is in the John G. Johnson Collection in the Philadelphia Museum of Art), from which the Museum's bronze was cast, was completed in 1889. Rodin said of this work that he wished to create a head so alive that it would impart vitality even to the mass of marble beneath it.

101. Minerva

1896? Marble, 22½ x 12¼ x 11½ in.

Sometime before 1888 Rodin met Mrs Mariana Russell, wife of the Australian painter, John Russell. In 1888 he made a portrait of her in wax. The classical purity of Mrs. Russell's features evidently appealed to him as the wax portrait was used as the basis of a number of representations of classical deities done during the next

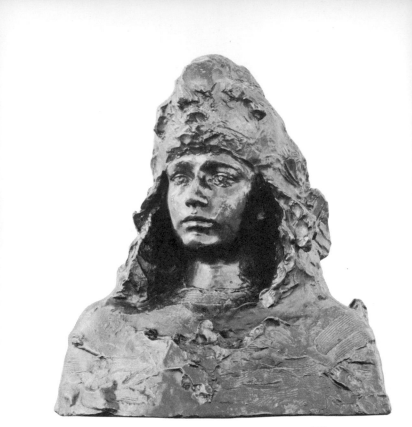

102

decade, including *Minerva*. This head, with its helmet and breastplate, is carved in yellowish marble and is, unlike the majority of Rodin's marbles, very highly finished.

102. Study for "La France"

1904. Bronze, 18¾ x 17 x 13½ in.

The head of this work, which dates from 1904, is based on the features of Camille Claudel, in spite of the fact that Rodin's relationship with her had ceased at least ten years before. In the definitive work for which this is a study, the head is placed in profile against a plaque. A cast was presented to the University of Glascow in 1906 with the title *St. George*. In 1912 another cast, entitled *La France*, was presented by the French people to the citizens of the United States to commemorate the tercentenary of the French explorer Champlain.

FRAGMENTS AND ASSEMBLAGES

Rodin's prodigal working methods left him with an abundance of "spare parts" — entire figures and parts of figures — that were stored on shelves and in drawers at the Villa des Brillants, Meudon, and utilized when the need arose. Among them are a large number of small anonymous heads, some of which were doubtless conceived in connection with *The Gates of Hell* while others were independent studies. Only one of the "spare" heads in this collection can be connected with a known project: on an enlarged scale, *Head of a Funerary Spirit* (no. 109) was used in the figure of The Spirit of Eternal Repose, which was to have been part of the monument to Puvis de Chavannes.

There are also a considerable number of partial figures, limbs, and torsos that were used in assemblages and, increasingly toward the end of Rodin's career, exhibited as independent works. To contemporary observers, such sculptures seemed to be unfinished; to Rodin, however, even the smallest fragment of the human body could constitute a complete sculptural statement, for he believed that every part of the body was equally expressive.

Among the fragmentary works there are probably more studies of hands than of any other part of the body. Toward the end of his career, Rodin used some of these unmounted studies in a number of symbolic works that have since gained considerable popularity (nos. 118–23). All of the Museum's hands in bronze, except numbers 116 and 117, were cast from enlarged marble versions.

103. Head of a Young Girl with Closed Eyes

c. 1885. Plaster, 9¼ (including base) x 5 x 5 in.

104. Mask of an Old Man

c. 1885. Bronze, 7½ x 5 x 5 in.

105. Head of a Laughing Boy

1889. Bronze, 6⅜ x 4⅜ x 5½ in.

106. Tragic Head

Mid 1890s. Bronze, 6⅝ x 4½ x 5 in.

107. Study of Two Heads and a Hand
Mid 1890s? Plaster, 4½ x 4 x 2⅜ in.

108. Head of a Slave
1898. Bronze, 5 x 3⅝ x 4¼ in.

109. Head of a Funerary Spirit
1899. Bronze, 6 x 4¾ x 5¼ in.

110. Torso of a Man
Mid 1880s? Plaster, 5½ x 3⅛ x 2¼ in.

111. Torso of a Man
Mid 1880s? Plaster, 10½ x 7⅛ x 3¼ in.

112. Headless Woman Bending Over
Mid 1880s?
[a] Plaster, 9 x 6½ x 5 in.
[b] Bronze, 9½ x 5⅛ x 4¾ in.

113. Seated Man
Mid 1890s? Plaster, 7¾ x 4 x 5¼ in.

114. Study for a Monument
Mid 1890s? Plaster, 20½ x 12 x 11 in.

115. Group of Three Figures
Mid 1890s. Plaster, 11⅝ x 9¾ x 7½ in.

116. The Clenched Hand

c. 1885. Bronze, 18½ x 11¾ x 8 in.

117. The Left Hand

c. 1885. Bronze, 18 x 10⅝ x 6½ in.

The intense emotions of anger and anguish shown in these hands make it seem most probable that they were made by Rodin from studies intended for *The Gates of Hell* rather than for *The Burghers of Calais* as is generally suggested. Early photographs show these hands placed on their side emerging from blankets as if they were the hands of invalids.

118. The Hand of God

1898. Bronze, 26¾ x 17½ x 21½ in.

Some years after making *The Clenched Hand* and *The Left Hand,* Rodin made a series of enlargements of his studies of hands. He discovered that the entire meaning of a hand could be changed when it was used with different terms of reference. In *The Burghers of Calais,* he used the same hand in two different figures in a gesture of despairing farewell. In *The Hand of God,* the identical hand, now holding two small figures, conveys the omnipotence of God and becomes a symbol of creation — both of God's power to create and of the creativity of the sculptor. The same hand also appears in *The Hand from the Tomb* (no. 122), emerging dramatically from the grave.

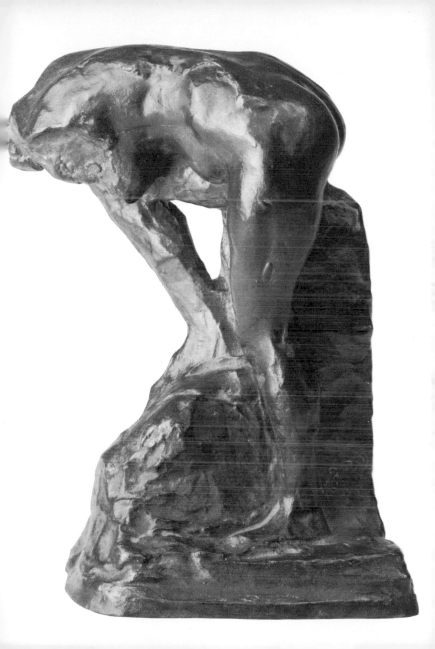

119. The Hand of the Devil Holding Woman

1903. Bronze, 16 x 25¾ x 19 in.

In his early life Rodin distrusted women, and like so many other intellectuals in the nineteenth century, often associated them with the devil. In this spirit, soon after completing *The Hand of God,* Rodin created its diabolical counterpart, *The Hand of the Devil Holding Woman.*

120. The Cathedral

1908. Bronze, 24½ x 10¾ x 11¾ in.

In the touching of two right hands, Rodin saw embodied the principles of Gothic architecture, of which he was such an impassioned admirer, while in the bony structure and slight pressure of the fingers, he saw analogies with the Gothic arch.

121. Two Hands

Before 1909. Bronze, 18 x 20⅞ x 12¾ in.

Here Rodin has grouped hands that are obviously male and female, contrary to his normal practice. It is for this reason that this work has been given the second, anecdotal title, *Hands of Lovers.*

122. The Hand from the Tomb

1910. Bronze, 23⅝ x 21¾ x 17 in.

In this work a hand, the same one used in *The Burghers of Calais* and *The Hand of God,* reaches out from an

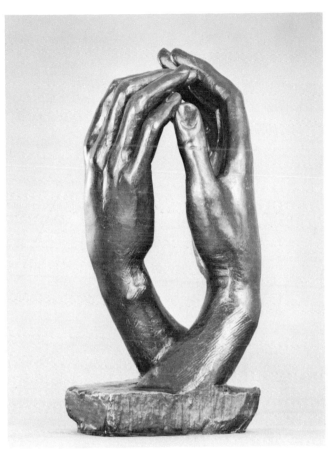

unnamed tomb. It has been thought to represent the hand which inscribed the writing on the wall of Belshazzar's palace.

123. The Secret

1910. Bronze, 33½ x 19 x 15¼ in.

Rodin saw hands as expressive instruments rather than functional extensions of the body. For this reason, the hands in his studies generally grasp empty air. In this work, however, the raised hands, greatly enlarged in scale, conceal a mysterious object from the viewer's gaze. As is very often the case, much of the spontaneity of the original sketch has been lost in the process of enlargement.

124. Hand of Rodin Holding a Torso

1917. Plaster, 6¼ x 9 x 3¾ in.

This composite work consists of a life cast of Rodin's hand made shortly before he died, into which has been inserted the cast of a small torso by Rodin.

DRAWINGS AND PRINTS

Rodin was as prolific a draftsman as he was a sculptor. In the last decade of his life, in fact, he did much more drawing than modeling. A very representative selection

Woman with Arms over Her Head
c. 1905
Ink on paper, 10 x 12⅝ in.

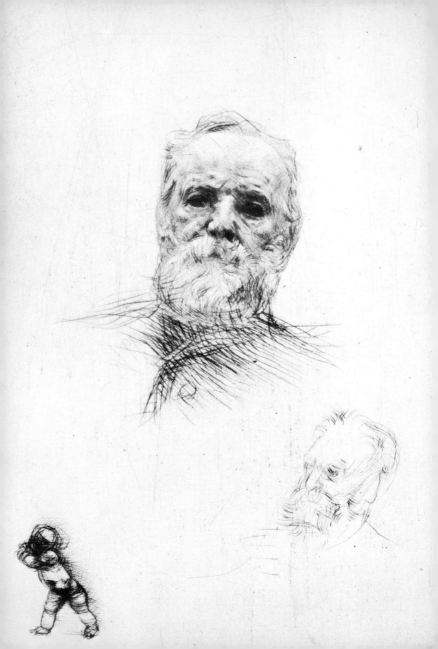

Victor Hugo (full face)
1884
Drypoint, 9 x 6¼ in.

of his drawings and prints is to be found in the Rodin Museum.

There is a fine group of "blacks" — drawings in pen and ink, wash, and gouache — done in the 1870s and 1880s on Dantesque and mythological themes. These fantastic scenes, done entirely from the imagination, are among the least well-known aspects of Rodin's work. In the latter part of his career, his attitude toward drawing changed entirely. He would work only if the model were before his eyes, moving freely about the studio. Many of the drawings were done without looking at the paper, in an effort to register the most fleeting movements of the model. These lightning sketches were then submitted to various treatments. In some cases, the contours were filled with a rapidly applied ochre wash to give the drawing "body." From others tracings were made, retaining only the most essential lines, which resulted in drawings of startling purity and simplicity. In the drawings of the final period, the pencil line is rubbed, the mysterious forms depicted emerging through silvery mists.

Rodin began to experiment with the graphic arts in 1881. While staying with Alphonse Legros in London, he made a drypoint, *Les Amours conduisant le monde*, on the back of one of Legros' plates. The drypoint

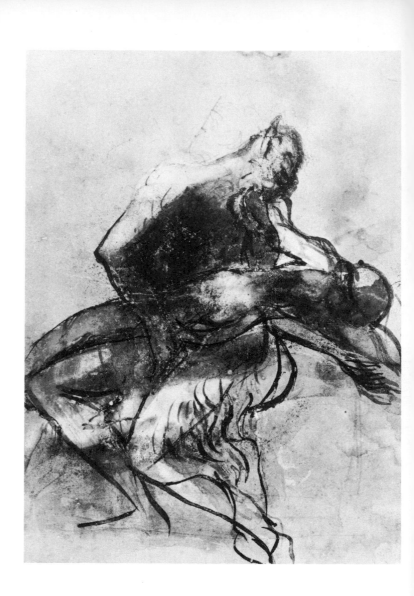

etchings that followed, which include the portrait of *Victor Hugo,* 1884, are notable for their sculptural definition of form.

Rodin's drawings were almost never preliminary studies for sculptures in the strict sense of the word. Drawing for him was an independent activity, a means whereby he could test his knowledge of the complexities of the human form. He was not interested in "style" for its own sake, but only for the truth it conveyed. Different as his sculptures and drawings are in mood — the one so three-dimensional and solid, the other so diaphanous — these two modes of expression must be seen as the obverse and reverse of the same burning desire to know the mysteries of Nature, that is to say, of the human body, intimately and completely.

Faun and Nymph
Late 1870s?
Pencil, ink, and gouache on paper
4⅞ x 3⅜ in.

INDEX OF WORKS IN THE MUSEUM

All references are to catalogue numbers of the sculptures

Absolution, 25
Adam, 4
Age of Bronze, 56
Andromeda, 34
Anxiety, 8
Apotheosis of Victor
 Hugo, 63
Assemblage of Heads of "The
 Burghers of Calais," 61
Athlete, 49

Bacchus in the Vat, 55
Balzac (studies for the
 monument), 64–67
Balzac in a Frock Coat,
 Leaning Against a Pile
 of Books, 64
Barbey d'Aurevilly, 93
Bas-reliefs for "The Gates of
 Hell," 13, 14
Becque, Henri, 80
Bellona, 99
Benedict XV, Pope, 95
Benedictions, 42
Berthelot, Marcelin, 87
Beside the Sea, 52
Burghers of Calais, 59–61
Bust of an Unknown Man, 74

Call to Arms, 58
Carrier-Belleuse,
 Albert-Ernest, 77
Carrière, Eugène, Project for
 a Monument to, 69
Cathedral, 120
Centauress, 20
Clemenceau, Georges, 94
Clémentel, Etienne, 96
Clenched Hand, 116
Colossal Head of Balzac, 67
Crouching Woman, 9
Crying Girl, 15
Crying Girl, Mask of, 16

Dalou, Jules, 78
Damned Women, 36
Death of Adonis, 39
Decorative Pilasters from
 "The Gates of Hell," 27, 28
Defense, 58
Despairing Man, 30

Ecclesiastes, 46
Eternal Springtime, 31
Eve, 7
Eve by the Apple Tree, 35
Eve and the Serpent, 35

Evil Spirits, 47
Exhortation, 50
Eymard, Father Pierre-
 Julien, 70

Faun and Nymph, 37
Fish Woman, 51
Flora, 97
Fording the Stream, 32
"La France," Study for, 102

Galatea, 53
Gates of Hell, 1, 2, 13, 14,
 27, 28
Good Spirit, 48
Group of Three Figures, 115
Guillaume, Eugène, 85

Hanako, 89, 90
Hand of the Devil Holding
 Woman, 119
Hand of God, 118
Hand of Rodin Holding a
 Torso, 124
Hand from the Tomb, 122
Hands of Lovers, 121
Harriman, Edward H., 92
Head of Balzac, 65
Head of a Funerary
 Spirit, 109
Head of a Laughing Boy, 105
Head of St. John the Baptist
 on a Platter, 21
Head of a Slave, 108
Head of Sorrow, 8
Head of a Young Girl with
 Closed Eyes, 103

Headless Woman Bending
 Over, 112
Helmet-Maker's Wife, 6
Hero, 44
Hindenburg, Countess
 Hélène von Nostitz, 84
Hugo, Victor, 63, 79

I Am Beautiful, 10

Joan of Arc, 8
Jupiter Taurus, 37

Kneeling Fauness, 12

Laurens, Jean-Paul, 75
Left Hand, 117
Legros, Alphonse, 76
Lorrain, Claude, Project for
 a Monument to, 62
La Lorraine, 98

Mahler, Gustav, 91
Man Awakening to
 Nature, 56
Man with the Broken Nose,
 Mask of, 71
Mask of an Old Man, 104
Medea, 29
Meditation, 19
Mignon, 72
Milo of Croton, 24
Minerva, 101
Minotaur, 37

Narcissus, 24
Nereids, 22
Nude Woman, 53

Oceanides, 54
Old Courtesan, 6

Poet and Love, 45
Polyphemus, 24
Polyphemus, Acis, and
 Galatea, 23
Possession, 40
Pulitzer, Joseph, 88
Puvis de Chavannes,
 Pierre, 82

Rodin, Mme, 72, 73

St. George, 102
St. John the Baptist
 Preaching, 57
Sarmiento, President, 68
Seated Figure, 41
Seated Man, 113
Secret, 123
Séverine, 83
Shade, 5
Shame, 25
Shaw, George Bernard, 86
Sirens, 22
Small Head, 11
Small Head of Pierre de
 Wissant, 60

Song of the Sirens, 22
Sorceress, 43
Sorrow No. 2, 38
Study for a Monument, 114
Study of Two Heads and a
 Hand, 107

The Thinker, 3
Third Architectural Model
 for "The Gates of Hell," 2
Torso of a Man, 110, 111
Tragic Head, 106
Two Hands, 121

Vanquished, 56
Vicuña, Mme, 81

Woman Combing Her
 Hair, 47

Young Girl Confiding Her
 Secret to Ceres, 48
Young Mother in the
 Grotto, 17
Youth Triumphant, 26

Zoubaloff Fauness, 33

Photographs of Rodin's works by Murray Weiss,
except cover by Philip Grushkin
and nos. 52, 112, and drawings and drypoint
by Alfred J. Wyatt (staff photographer)

Designed by Philip Grushkin
Edited by George H. Marcus
Printed by The Drake Press